G8

Living in a Wild Garden

Small Annual Nettle, URTICA URENS, formerly eaten as a vegetable

Linnaeus ate young shoots in spring

Rose Bay Willowherb
CHAMAENERION
ANGUSTIFOLIUM

Stinging Nettle, URTICA
DIOICA, pick young shoots with care

RB '79

Living in a
Wild Garden

ROGER BANKS

WORLD'S WORK LTD
THE WINDMILL PRESS
KINGSWOOD TADWORTH SURREY

Acknowledgements

Among countless people who have helped in one way or another
to make me aware of the possibilities of ordinary plants,
my thanks are due especially to:

Jim Bingley, Warden, Flatford Mill Field Centre,
David, 28th Earl of Crawford & Balcarres,
 late Chairman of The National Trust,
R. M. M. Crawford, Professor of Botany, University of St Andrews,
Mary Grierson, The Royal Botanic Gardens, Kew,
 who teaches me to paint,
R. J. Mitchell, Curator, St Andrews University Botanic Garden,
Molly Sutton, who has typed with such understanding.

Calligraphy by Margaret Fenemore Clark

Text and illustrations copyright © 1980 by Roger Banks
Reproduced, printed and bound in Great Britain by
Fakenham Press Limited, Fakenham, Norfolk

SBN 437 01200 X

For my wife,
who never knows what she might find
on the kitchen table next,
and without whose constant help
this book would never have been written.

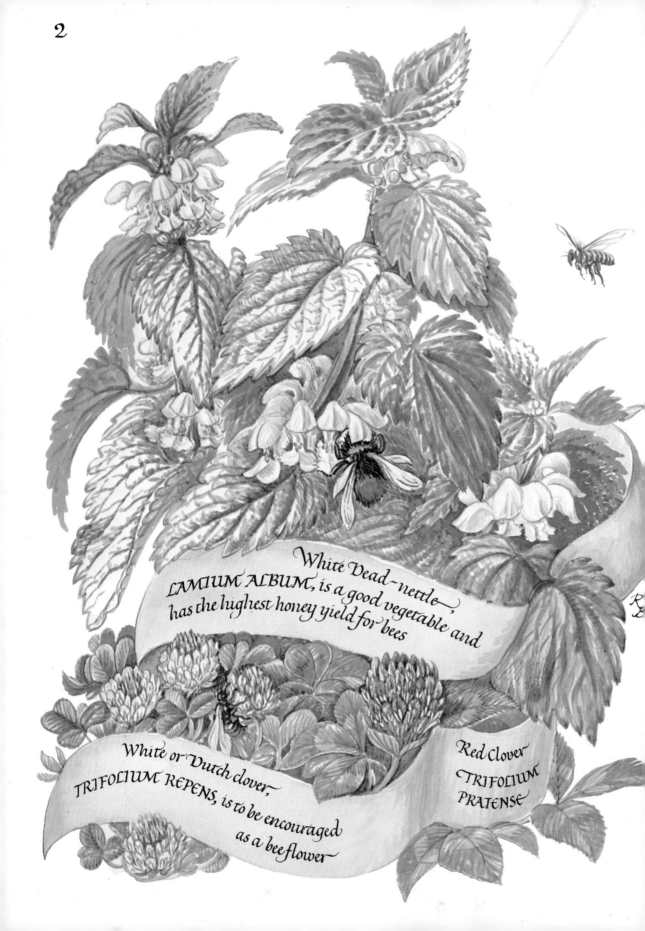

White Dead-nettle,
LAMIUM ALBUM, is a good vegetable and
has the highest honey yield for bees

White or Dutch clover,
TRIFOLIUM REPENS, is to be encouraged
as a bee flower

Red Clover
TRIFOLIUM
PRATENSE

Working on the principle that human nature being what it is, we never value anything until it is taken away from us, I shall begin in the Antarctic. Living for two years with the Falkland Islands Dependencies' Survey in a world devoid of plant life taught me to look at each leaf as if on the day of creation. Even the smell of the land and things growing is unbelievably strong if you have lived without it.

In the same paradoxical way, painting the Antarctic made me a flower painter. If one is heavy-handed with an iceberg, it looks like a flint: if you are used to recording sunlit glaciers, you find that the tumbled complexity of pinky silver petals at the heart of a *Gloire de Dijon* rose presents exactly the same technical problems of transparent form, high tones and reflected light. A third invaluable lesson is speed; even on summer days of ultraviolet heat, with shirts off and perhaps a quick swim, the Antarctic temperature is never high enough to paint outside in watercolour and in winter, with fifty degrees of frost and a wind, you cannot stand still to draw for more than ten minutes. You must go for the essential line and capture the rhythmic spirit of the thing as best you can. The same goes for flower painting. The flower you started with in the morning, even under ideal conditions, is going to have opened into quite a different shape by midday and in some cases died by evening. A fluent technique is imperative and for ten years now I have been striving to perfect it.

This then is the botanical artist's eye which I bring to appreciate the garden but, because painters are poor and must live and both my wife and I happen to like good food, I bring as well an appreciative tummy. Lastly, because unsubstantiated generalisations are a bore and no-one can speak from any point outside their own experience, this book is largely about Dalgairn.

In 1964, for £3,000 – three years' rent of our London flat – we bought an Adam mansion with twenty acres of Scottish grassland, woodland, walled garden, cottages and outbuildings, lock stock and barrel. The property had been on the market for a year and although it is within a mile of the market town and main line station, nobody wanted it except the demolition man for its site value. There was nothing much wrong with it that a little care and attention couldn't put right.

Living in a Wild Garden

For fifteen years now my wife and I have been wrestling with its problems; making flats, scrounging bits of junk and other people's chuck-outs to furnish them. Never really being able to afford to do things as they should be done gives one a sense of achievement wholly lacking if one can just buy things from a shop. The chair I sit in was rescued from a bonfire, the cushion was a hair mattress on a dump and the old leaden flower containers which lend a touch of gracious living below every Georgian sash window on the south front were pig-trough liners thrown into a ditch.

Outside it has been a similar story. Anyone who could afford the four gardeners the place was designed for would have been off to a tax haven years ago. Obviously in the old days a daily selection of fruit and vegetables was brought, cleaned, to the back door downstairs where another team of indoor servants ran the house and cooked. Those days are an age away: we live in the era of high wages and limited fossil fuels and have been forced to adapt. I find that the gains outweigh the losses and I wouldn't care to return to the discipline of servants.

More significantly we live in an age of agricultural revolution when the countryside itself can no longer be taken for granted. Wood and hedgerow, wayside pond and ancient pasture are all disappearing with their associated wild flowers so there are changed priorities in the garden. Traditionally when all around was wild and rough, the gardener sought to impose order in his little domain; nowadays when factory farming is here to feed a hungry urban world, the gardens of caring people must be conservation areas – little vegetable arks.

I never use weed- or insectkillers and poisonous sprays if I can possibly avoid it because, as a naturalist, I'm only too alive to the damage carried up the food chain. Anyhow, I rather like creepy-crawlies for their own sakes and should be sorry to find no room for them on my ark.

This then is the ground I wish to cover in this book, the triangle between the obvious rural charm of wild flowers, ordered cultivation in the garden, and the kitchen. Usually it is a rubbish dump but I make no apology. In an over-tidy world it is on just these waste lots, often at the city centre, that one may find something of interest, useful or good to eat.

The colour plates are in no particular scientific order because wild life is like that. There are countless excellent books of botanical classification and tidy gardening but the plants themselves don't seem to care for it.

They tend to grow all muddled up and often hybridise with a promiscuous abandon that is the despair of taxonomists. I find philosophical acceptance of this with a dash of humour easier to live with in the long run. You may go out looking for mushrooms and find none but fill your basket with a nice little picking of redleg and chickweed. Does it really matter? You may plant tidy rows of vegetables like the book says and find them doomed by a dozen deadly fates but, if that same fate causes a crop of delicious toadstools to spring up instead, who is the loser?

I should like to take each reader by the hand and lead them step by step round the garden, over the rubbish tip and into the kitchen, but as that cannot be, I have painted plants more or less as I found them and talked about their uses as we go.

Because correct identification is vital, I have arrowed species' distinguishing characteristics in my illustrations and put in poisonous species likely to be confused with them as well, indicated by a purple label. This should be enough for any ordinarily sensible person, though, of course, there is no guarding the man who, before lapsing into a coma said he'd eaten 'blackberries'. My pathologist friend was up all night before he eventually identified the blackberries as black berries, deadly nightshade. However, to turn our backs on the host of edible plants and delicious fungi because of such unfortunate incidents is like refusing to cross the village street because you've heard of a motorway pile-up. Take care and proceed with due caution.

Deadly Nightshade

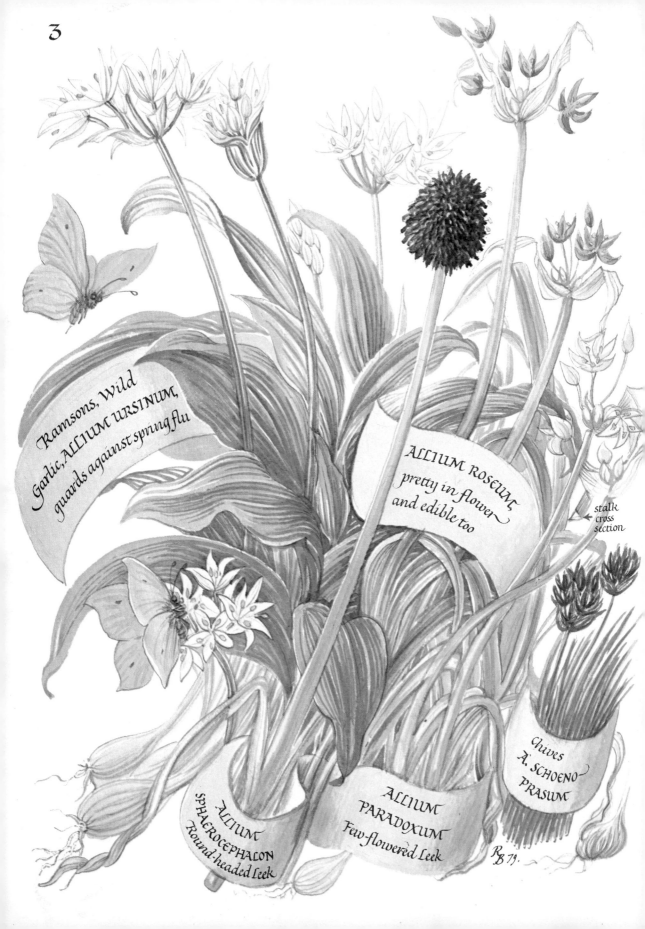

Ramsons, Wild
Garlic, ALLIUM URSINUM,
guards against spring flu

ALLIUM ROSEUM
pretty in flower
and edible too

stalk
cross
section

ALLIUM
SPHAEROCEPHALON
Round-headed Leek

ALLIUM
PARADOXUM
Few-flowered Leek

Chives
A. SCHOENO-
PRASUM

RB 79.

When my wife and I first came to Dalgairn, the house had been empty for a year. No vegetables had been planted in the garden and we were too busy with everything inside to plan ahead for spring.

It was cousin Mary by divorce when she came to stay at Easter who first got us on to stinging nettles. She's a cousin of my wife so distant that we once totally confused ourselves trying to work out the relationship, perhaps that's why she's a favourite. When she said 'We must all eat nettles; we did in the war. Find me an old glove', we did and thereby crossed unknowingly into another, older, more delightful world of people who are always on the look-out for something free to eat rather than being tied by the nose to the dreary compulsion of shopping.

Nowadays, anyone looking in the hall drawer at the array of single green-stained gloves would deduce the house to be inhabited by one-armed vegetable monsters – the sort of thing Dr Who has to deal with. In practice the other hand holds the bucket as we rush out like devils possessed on the first warm days of spring. Cousin Mary by divorce is perfectly right: we did do things in the war to help ourselves, as any Cabinet Minister whose sympathies did not lie halfway to Moscow would have the honesty to say loud and clear today. Some people will tell you that stinging nettles are stringy: they have picked them too late, and indeed, old nettle stalks used to be woven into coarse cloth in the Middle Ages. Only the first growth, just the top three or four inches, is the one to eat.

Pick more nettles than you think you'll need because they cook down to nothing like spinach. As bits of old leaves, sticks and soil are hard to dislodge from the hairy shoots without being stung, gather nettles with care. Wash them if you must and boil them for a few minutes in an inch of salted water. We enjoy them as a vegetable, especially valuable in what John Seymour calls 'the hungry quarter of the year' – when winter's store has run out and prices in the shops are sky-high for imported rubbish, forced and tasteless, before our own can get going again in summer. Serve them loosely chopped with a knob of butter and a dust of pepper and nutmeg. So that pepper comes out really spicy, my mother's tip was to pop two or three cloves in with the peppercorns as she filled the mill. The difference it makes is out of all proportion to the trouble taken.

Nettles are known to be specially rich in nitrogen which is why the

abandoned wilderness of many a derelict garden has surprising crops of fruit on its unpruned, untended bushes, if you can once penetrate the sea of stinging nettles surrounding them. I haven't yet gone so far as to *plant* stinging nettles but certainly if they are there in the midst of a great clump of roses, getting them out is a low priority. When you can see how they all thrive together it seems a better use of my limited time to tip a barrowload of dung and leaf-mould and a handful of marigold and honesty seeds to join the party.

This treatment seems to work very well with any of the trouble spots of an old garden. Rotten stumps were our particular problem. Faced with a big old stump your choice lies between violence and philosophical acceptance of it. You need to use either gunpowder and bulldozer or a spirit of passive adaption. I have tried both and, in either case, the real nuisance remains the same as the unseen roots decay and transform the ground into an invitation to every little burrowing beast to move in to make use of the holes, and traps for the grass cutter. Rather than alternately blunting the blades on gnarled roots or losing wheels down vole holes, it seems better to declare the immediate vicinity of a stump a No-Go Area and ring it with roses. Old-fashioned shrubby sorts do best; anything out of Redouté such as *Rosa damascena,* the Damascus Rose of the Crusaders, or *Rosa francofurtana,* developed at Malmaison as the *Souvenir de l'Imperatrice Josephine.* As they need no pruning they are ideal for transforming lawn stumps into low thickets for robin and wren to nest in, whereas the five-feet-high, purple and white striped *Variegata di Bologna* will overtop the rankest nettle in the rough. *Rosa Paulii* with its strong downward-flowing growth habit, will cover the most outrageous stump and provide nesting sites a little higher up for blackbird and thrush.

Even if your garden lacks up-ended stumps ten feet high and you don't go along with the Roman treatment for rheumatism, alternate steam baths and flogging with nettles to stimulate the circulation of the blood, there's no reason why you shouldn't stimulate the scalp by massage and a few boiled nettles in the rinse water for your hair. Audrey Wynne Hatfield recommends rotting down a few nettles in the water-butt to make a complete fertiliser and effective spray against aphis as well as placing cut

nettles on the compost heap. When all the herbalists from Pliny to Culpeper have extolled nettles, and even Pepys enjoyed nettle porridge in spring, it seems silly of us to have lost our appetites for one of the world's plants most rich in chlorophyll.

Another excellent way of using nettle shoots is for soup. Cook them with a cube of meat extract, then liquidise, adding cream and lemon juice to taste just before serving. This freezes very well and can be raised to gastronomic distinction by throwing in a bunch of Wild Garlic or Ramsons, *Allium ursinum* L. This edible relation of poisonous lilies of the valley appears in shady woodlands in early spring and flowers similarly in June with elegant clusters of white stars instead of little creamy bells. The tufts of green leaves look alike, too, only the smell is unmistakably rank. We use it in salads, chopping up a bunch of leaf-shoots any time between March and midsummer, just the time of the year when 'shop garlic' is hardest to get; one has got through the winter plait on the kitchen wall and the new season's hasn't yet grown.

Garlic tolerance, or otherwise, seems to be largely a matter of fashion for different generations. The young don't seem to mind it in the right place: delicious hot garlic bread for picnics rather than before going to a dance. Some of my older relations, on the other hand, complain that even our dogs smell of garlic and swear that our eggs are tainted and not even good for cooking. I believe this imperfectly but to carry out consumer tests with otherwise identical sponge cakes would hardly make for family harmony. Anyhow we are unrepentant as, like the garlic-eating French and Italian peasants of the First World War, who couldn't understand why the troops in the British trenches alongside were so decimated by the epidemic of flu in 1918, we seem to have a higher resistance to flu and rheumatic diseases.

There are other species of nettles and garlic, all more or less edible and to be tolerated if not actively encouraged in the garden. The little Annual Nettle, *Urtica urens*, usually comes up in a mass of seedlings on open ground and quickly, so it is tender and well worth gathering for the pot before you hoe.

In the depths of winter it's worth keeping a sharp look-out for the small

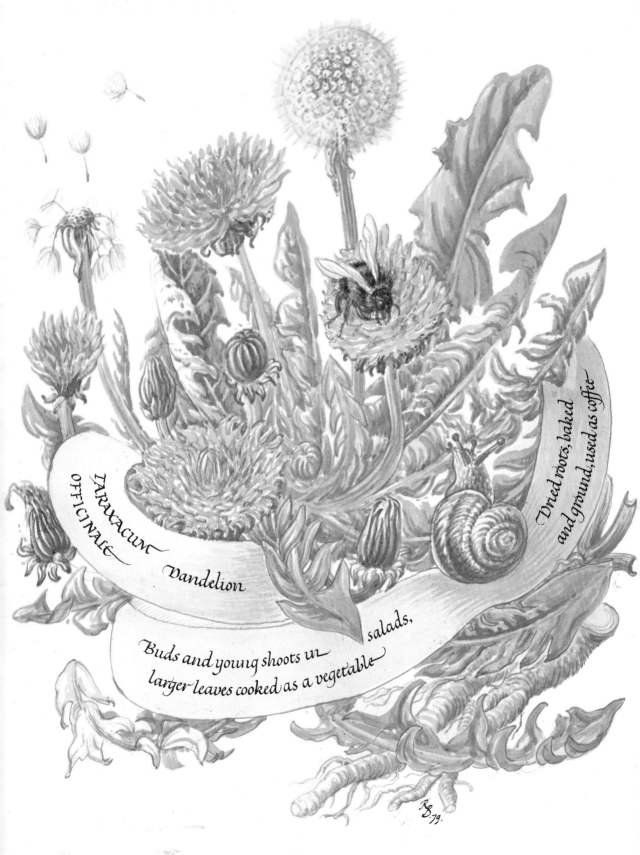

TARAXACUM OFFICINALE Dandelion

Dried roots, baked and ground, used as coffee

Buds and young shoots in salads, larger leaves cooked as a vegetable

RB. '79.

Purple Dead-nettle, *Lamium purpureum* L., which grows in the same sort of situation, just inside a farm gate, at the edge of a ploughed field or on a bit of fallow ground you are just about to dig, and you can eat it too. If it is no great delicacy for our table, it is for the bees, flowering early in the year when there is nothing much about to replenish their winter stores. If you watch for a few moments on a fine spring day you will be surprised to see how the honey-bees work over a seemingly insignificant patch of Purple Dead-nettles. The reason is because the hooded and lipped flowers, labiates, have some of the highest honey yields of any in Britain, the overall record going not to heather, clover, orange blossom or any of the garden favourites, as one might suppose, but to *Lamium album* L., White Dead-nettle, the common old non-stinging nettle found by every wayside and hedge. When you realise that it is thus one of the best plants you can grow, you begin to keep your eyes open for odd seedlings or even just hunks of Dead-nettle-infested turf from the rubbish dumps which can be lifted and transferred to colonise suitable sites on rough ground.

The larger Red Clover, *Trifolium pratense* L., makes handsome clumps in rough grass and the smaller White Clover, *Trifolium repens* L., settles happily in lawn grass. 'Repens' means creeping and, like daisies, I have never seen why gardeners want to eradicate them from any but the finest bowling green. My wife can nearly always find a four-leafed clover, which makes any patch of grass she is sitting on far more interesting to children than the sort of lawn depicted in advertisements. Clovers of all sorts being among our best honey-yielding flowers for bees, it seems a shame not to encourage them along with nettles in odd corners of the garden. When I see the extent to which clover carpets motorway embankments I can't understand why we don't have apiaries adjacent.

There are several species of the garlic tribe one can grow to advantage in the garden besides the Chives, *Allium schoenoprasum*, familiar in every kitchen plot and window box, and Ramsons which will grow themselves. Crow Garlic, *Allium vineale*, with its cluster of stalked rosy flowers and bulbils in a papery hood, is found in dry grasslands of the south-east and will settle happily on wall-top, bank or rockery. Likewise, the Round-headed Leek, *Allium sphaerocephalon*, with purple globe heads an inch

across is a rare wild flower in Britain so should not be disturbed. I picked ours up in a lay-by near Trieste whilst waiting to get Italian petrol coupons at the Yugoslav frontier. They objected neither to exchanging the Adriatic coast for Scotland nor to annual pillage by dried-flower arrangers and are still with us ten years later. The Three-cornered Leek, *Allium triquetrum*, like a white bluebell, distinguished by the triangular section of its stalk, grows in the woods of the south-west, but, best of all for my purposes, the Few-flowered Leek, *Allium paradoxum*, a rare species with triangular stalks, white bells on peduncles of varying lengths as well as bulbils, is to be found in several places around the Firth of Forth. One patch lies on an approach road to the M90 so, as the plant is gregarious, with its bulbils dropping off to colonise an ever-widening patch, I hold it no crime to break off the seedling-threaded turf at the roadside, saving the roadman the job of having to trim it.

Even if you don't practise a garlic cuisine it is as well to come to terms with it in the garden. An old gardening friend decided to have a primula dell in a tree-shaded corner by the burn and to eradicate the Wild Garlic. This daughter of the regiment and the Raj ran her garden like a series of military exercises so, for a septuagenarian, she had a curious battery of gardening tools. There was a flame-thrower, so that she could go for entrenched weeds like Chindits tackling Japanese foxholes, and a rabbit-gasser so that she could campaign in winter up and down a precipitous muddy bank against the furred enemy under the rhododendrons.

'Come along, Roger, keep the pressure up. I think there are still some we've missed'.

She would scramble up the bank like a monkey, leaving me to follow with the heavy cylinder.

So, when it became the turn of the Wild Garlic, her determination meant something. Every spring she would lay about her – with sodium chlorate, Paraquat, Verdone or whichever expensive new secret weapon had been recommended.

'Come along, Roger, you're not really trying. Pump harder. I want to give those big clumps a double dose'.

Each autumn, choice and even more expensive varieties of primula

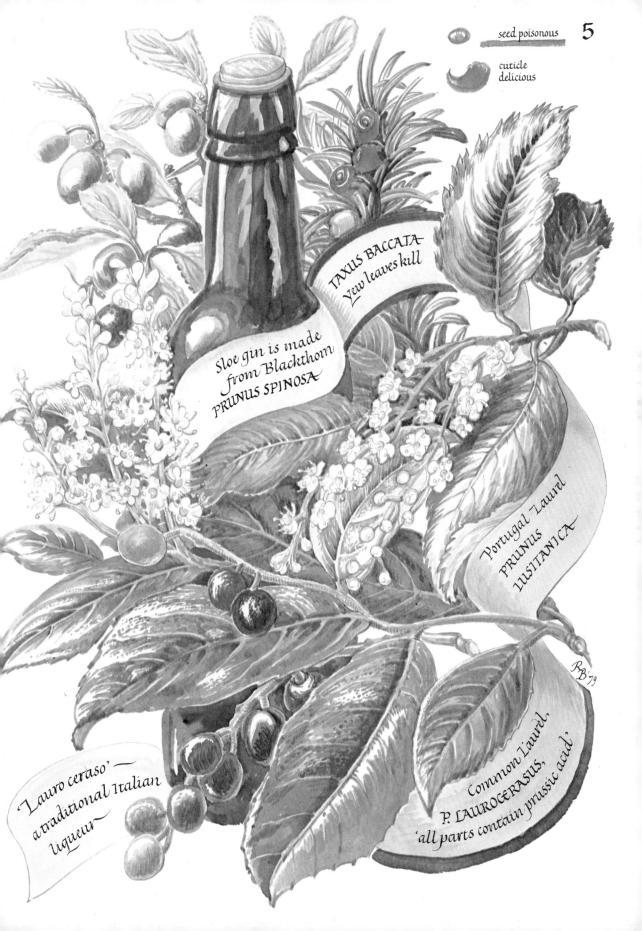

seed poisonous

cuticle delicious

TAXUS BACCATA
Yew leaves kill

Sloe gin is made
from Blackthorn
PRUNUS SPINOSA

Portugal Laurel
PRUNUS
LUSITANICA

'Lauro ceraso'—
a traditional Italian
liqueur

Common Laurel,
P. LAUROCERASUS,
'all parts contain prussic acid'

RB '79

ordered from the Chelsea Flower Show were planted out to 'naturalise' in the deep leaf-mould, and the following spring, just as regularly, up would come the garlic. In the end this battle was only to be resolved by death; though she herself never surrendered and died fittingly 'on campaign'. She had sprayed on so much sodium chlorate that she poisoned the exposed roots of large trees on the rocks at the top of the bank: her gardening efforts caused such a landslip that the whole woodland dell, path and all, avalanched down into the burn. Now Wild Garlic grows even more thickly on the exposed slope to make her lasting memorial.

Three-cornered Leek

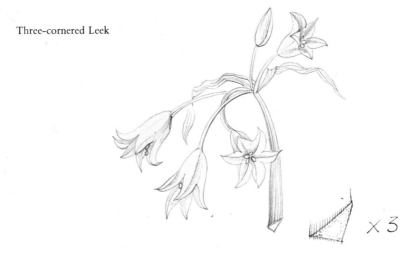

× 3

As any gardener knows there are weeds and weeds of unprintable awfulness. Ordinary weeds, after half an hour's hoeing down the rows of vegetables or a little ladylike hand-weeding of the herbaceous border, turn up their toes to expire in the sun. This section deals with the sort of weeds which cause lady gardeners suddenly to remember pressing appointments and their menfolk to recollect all the things their doctor said about hearts and hernias, bad backs and ruptures.

Because these weeds have deep-rooting systems they spread under-

ground in the most furtive way. An ordinary weed is killed by being chopped up and dug into the earth: to a baddie this is merely a signal to sprout more shoots. An ordinary weed packs up under a defoliant spray: a baddie retires into the earth for a little than counter-attacks from its deep roots, utilising some chemical sprays as fertiliser. A ten-feet-high wall or a five-feet-wide garden path regularly sprayed with an anti-weed steriliser will deter any weed with a shred of modesty: a real baddie will tunnel straight under such obstacles with the brazen disregard of a manic super-mole. The apotheosis of all baddies was the dreaded Sukebind in Stella Gibbons' 'Cold Comfort Farm', coiled under the hedges and choking the ditches, lying in wait to ensnare the village maidens for a fate worse than death on midsummer nights. If only it existed, of course, I'd grow it but I must leave such happy fantasies, brought to heel, alas, by my better half asking in a voice of unmistakable edge what I intend doing about this bit of awfulness and that dreadful corner.

Rose Bay, *Chamaenerion angustifolium* L., the largest of the Willowherb family will always be remembered affectionately by those who recall how rapidly it colonised mile after mile of charred ruins after the London blitz. Because its graceful pink spires are always the first to bloom on burnt earth, it is also known as Fireweed in Canada, its original home. As the last flowers open at the top of the stalk, the long curved seedpods lower down are already ripe and ready to explode with floating thistledown. With the first frosts these pods turn to brightest crimson and the tiered lanceolate leaves change through every shade of yellow and red to scarlet. Such a magnificent plant would be on every recommended seed list for autumn colours, were it not only too successful in propagating itself.

I think I can safely place it at the head of our worst weeds in the more heavily forested northern half of Britain because we seem unable to manage our woodlands on the Continental pattern of periodic thinning with natural regeneration always being ready to take its place. Our little plantations of softwoods all felled by one clean sweep expose the woodland floor and give the Rose Bay its chance – made even better if a bit of broken bottle suddenly exposed to the sun's rays among the wood-chips and sawdust starts a fire. Once established, a good patch spreads its

19

thistledown so profusely that, on a sunny October afternoon, one may be easily mistaken in thinking one sees clouds of smoke drifting across a forest clearing. As if this were not enough, Rose Bay spreads itself by tough underground runners as well.

One can do so little about seeds on the wind: it is too late unless you have already replanted young trees which will grow large enough quickly enough to keep their leading shoots ahead in the race with the Willowherb. If you once allow that rising tide of pretty pink death to top a new plantation even young saplings several years old will be carried down by the sheer weight of lolling foliage, so that, even if not killed, they will eventually grow up weak and twisted. Prevention is preferable by never allowing the natural ground cover to dry out or become too thin: nature will always fill a vacuum at the first opportunity, and that usually means Willowherb. There are plenty of places such as sand-dunes where its propensity to colonise dry soil can be turned to advantage. Its strong network of roots has a stabilising effect and the high honey yield of its great quantity of flowers can be as good as heather in strengthening the bees for winter.

As might be expected, at Dalgairn we found the worst situation; our vital shelter wood had been cut two years previously and not replanted. They had been old trees long past their prime.

'They wasna' worth saxpence,' Moir, the ancient gardener we had taken on with the house, declared and spat in disgust at the tell-tale rotten stumps. Friends inspecting the acres of heaving mud churned up by the timber lorries were agreed.

'Well, since you mention it, it did remind me of the Somme in 1916, but I didn't want to be the first to say so!'

A farmer friend offered me a plough but as the area was technically 'garden' one didn't know where to start and stop. Even if one had been able to plough the odd hundred-yard stretch, one would have run up against a drive, fine old rhododendrons or a telegraph pole that we wished to keep.

So we scythed and planted and scythed again, eventually sorting the land into woodland shelter, which we desperately needed, and rough grass which would look tidy and bring the Willowherb under control alongside the new access drive which we had had to make.

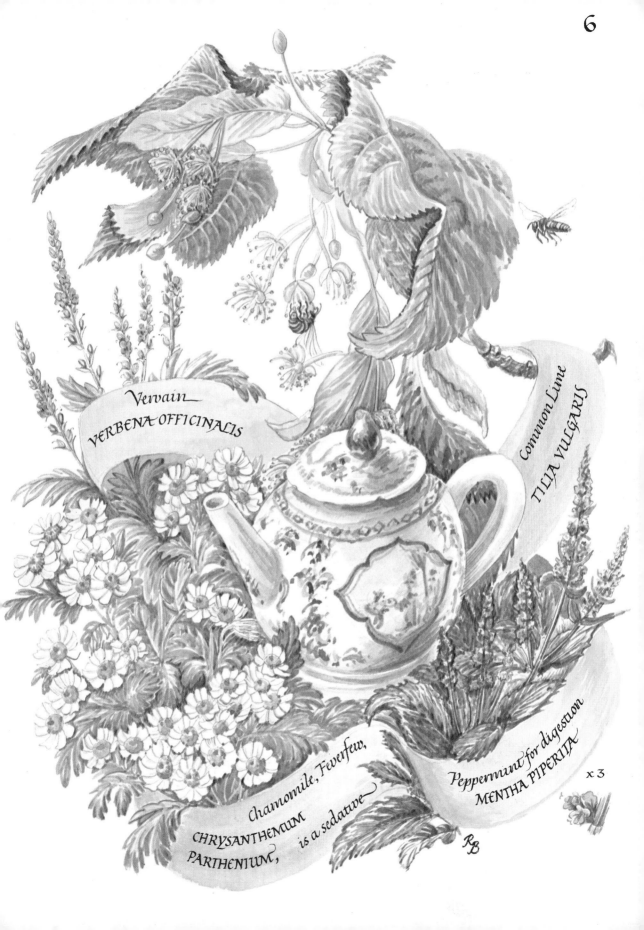

Vervain
VERBENA OFFICINALIS

Common Lime
TILIA VULGARIS

Chamomile, Feverfew,
CHRYSANTHEMUM
PARTHENIUM, is a sedative

Peppermint for digestion
MENTHA PIPERITA

x 3

RB

But Willowherb is another of the weeds one can eat. The great Linnaeus recommends the leaves but I've found them tough and perhaps in Sweden he wasn't so anxious to eat the enemy on sight as I am. I advise you in sheer self-defence to watch out for the first shoots and pick as many as you can: if they are only three-inch tips they will be the most tender and suitable for experimenting with any of those Chinese dishes which call for the use of unfamiliar shoots.

Used with imagination, Willowherb could rise to gourmet heights, but even when steamed till tender and dished up in a hurry with a knob of butter, lemon, a squirt of soy or a splash of tomato, anyone can get by, feeding the family and saving themselves the price of vegetables in spring as well as the time spent queueing for them. Surely people don't need a blitz to make them appreciate Willowherb?

Willowherb shoots

It was my daughter Thomasina who caused us to remember first eating dandelions. It must have been in 1967 that there was a £25 currency restriction abroad because, suddenly realising she was entitled to an allowance, we took her to France for her third birthday. Three hours past bedtime she was still wide awake in Paris, so we placed her on a red plush banquette in the restaurant of the *Gare du Lyons* while we had dinner. As she lay back spellbound under that wonderful *fin de siècle* ceiling, *Salade de Pissenlit* was served: the idea of dandelions being called Wet-the-Bed, and eating them in the middle of night undid all the good effects of Nanna's training and 'Life' began.

Now, whenever I find a flourishing clump of dandelions in the garden, instead of going to get a spade, I find a pot or box under which to blanch it. If you look underneath a few days later you will find a host of tender shoots have been forced up in the dark; leaf, bud and stalk are all good to eat, if not old and tough, but don't forget to put in a few anti-slug pellets beforehand or they will eat them first. As for dandelion's old reputation as a diuretic, I have never noticed it. Granted, we have only eaten dandelions in moderate quantities, but if a child of three is unaffected, it can't be all that bad.

The way to make de-caffeinated coffee – Café Haag – is to wash dandelion roots well and dry them in wind and sun before baking in a slow oven till brittle, then grinding like ordinary coffee.

If you know of a good patch of dandelions, big enough for you to gather a couple of pounds when they all come with a rush after warm spring weather, it will probably be in a city, in a railway yard or by the gas works, because dandelions thrive on smog with plenty of sulphur in it. Dirty dandelions need a good wash and to be boiled so I prefer a Lebanese recipe for Dandelions in Oil, Hindbeh. Boil 2 lb of leaves till tender, strain and squeeze out excess moisture. Mix with $\frac{1}{2}$ cup of olive oil, $1\frac{1}{2}$ cups of chopped onions and salt to taste and fry, turning over the mixture to prevent it burning. Hindbeh should be served cold with lemon but, in our climate, it can just as well be eaten hot as a sort of Beirut bubble and squeak – terrorists' hot-pot!

Dandelion

23

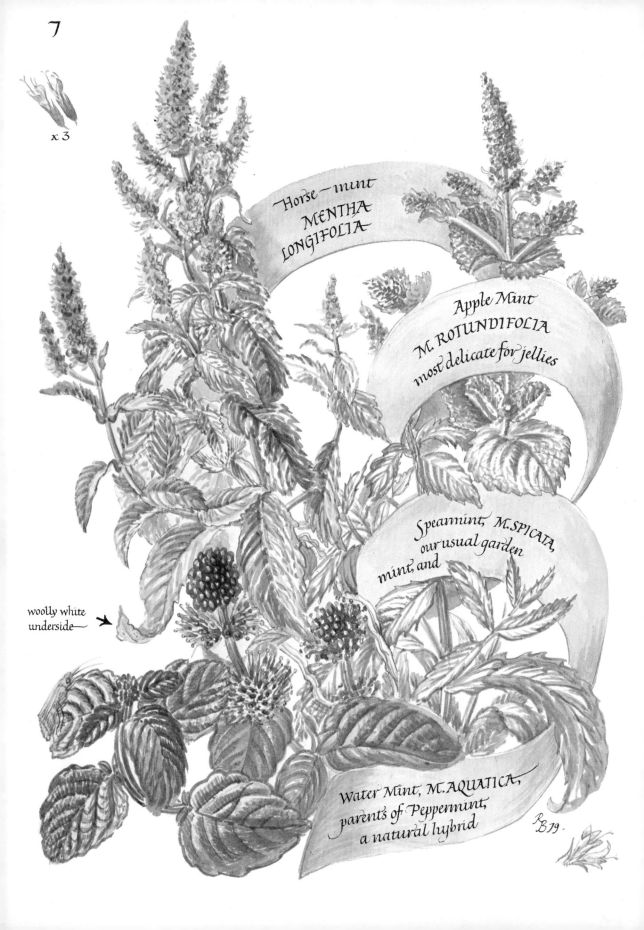

x 3

Horse—mint
MENTHA
LONGIFOLIA

Apple Mint
M. ROTUNDIFOLIA
most delicate for jellies

Spearmint, M.SPICATA,
our usual garden
mint, and

woolly white
underside—

Water Mint, M. AQUATICA,
parents of Peppermint,
a natural hybrid

RB 19.

Gean

Like most old gardens, Dalgairn had its full complement of aged laurels standing black and gloomy in smut-laden shrubberies for most of the year and needing to be clipped at others. I ignored them for as long as possible.

If you look up Laurel in a garden book you'll get *Laurus nobilis* L., which most people call Bay and use in cooking as the corner-stone of their bouquet garni – you used always to be able to snip a bit from tubs outside the Ritz in an emergency. Start again with *Prunus* – no one ever says how you're expected to know – and after such delightful trees as *Prunus avium,* Gean; *P. cerasus,* Sour Cherry and *P. padus,* Bird Cherry you come to *P. laurocerasus* L., Common or Cherry Laurel and *P. lusitanica,* Portugal Laurel. If they aren't as usual clipped and tortured into unrecognisability both grow into graceful flowering trees. The creamy flowers are carried on racemes in spring; Common Laurel's usually stand up while Portugal Laurel's hang down and Common Laurel has a larger, glossier, almost parallel-sided, leathery leaf. 'A poisonous plant; all parts contain prussic acid, hence the crushed leaves have been used by entomologists to kill insects; the leaves are used for making wreaths' says Dr Polunin and we had never had cause for doubt till we were in Italy being given very good home-made liqueur which tasted of marzipan. We complimented our Istrian hostess and asked about it.

'*Lauro ceraso,*' she declared.

'*No-no.*'

'*Si-si,*' she reaffirmed.

'*Lauro ceraso molto veinoso, morte per tutti!*' We replied haltingly but firmly in our best Italian and rolled our eyes expressively as if in the throes to make up for our grammatical inadequacies. She shrieked with laughter and poured us each another glass before taking us out to show us the tree growing just as they do here in the grounds of Victorian hospitals. I still thought there must be some mistake: St Lucy's Cherry, *P. malaheb,* with more clustered berries, the one whose wood is used for pipes and walking sticks, is the one you are supposed to use. At length, in the fulness of the summer season, the laurel cherries ripened and the year's liqueur was made so, notwithstanding what the book says, we now do likewise at home, though one has to make sure to get the berries in before the frost

25

Beech

here and ripen them off inside. I have done it for years now without ill-effect but, when people start to pour themselves a third glass, one can always make a light allusion to the amount of prussic acid in their drink.

Sloe, *Prunus spinosa* L., or Blackthorn is a triple blessing for any garden. Its cloud of white blossom on the bare twigs is among the earliest in spring; its tough thorny growth makes an impenetrable hedge for birds to nest in and, in autumn, its little bitter bloomy plums make a fine liqueur.

If you buy sloe gin in a shop it is thin stuff which doesn't seem to have much point, nothing like the real thing. Making sloe gin is a good holiday job because you are out in the sun picking sloes and you need lots of time to prick each one thoroughly. Pack as many bottles with well-pricked sloes and brown sugar as you can afford gin to cover – one bottle does for three – and pack them under the seat of the car. This ensures that they get a good shake-up: the book says 'turn daily for a month or so'. When the sugar has all dissolved, strain off the liquor, bottle and seal for two years. Never waste the residue of good alcoholic sloes or anything of that sort. Use them instead of juniper berries with belly of pork to make Terrine de Campagne, rough country pâté, the deliciousness of which belies its frugal ingredients.

Yew was another slow-growing tree which we have in abundance. Farmers hate yew because their livestock is sometimes so stupid, remarkably stupid, animal instinct considered, as to eat any small branches or clippings, the smallest amount of which proves fatal. This unfortunate attribute of the leaves is also applied, quite wrongly, to the scarlet fruit. I have always been grateful to my nurse who first introduced me to this interesting fact of life, because it taught me not always to believe what people say without tasting for myself. To eat yew berries and still be alive next day without ill-effects gave me my first yardstick against which to measure the accepted prejudices of the world. You may be quite sure that how to teach your charges to eat yew berries does not feature in Norland's nursery curriculum, but then our Nan was an exceptional girl. For a tiny taste of sweetness, too small to be of use in the kitchen, you have delicately to bite off the gelatinous red cuticle, discarding the pip inside. Failure to do this means, I imagine, mustard and water, stomach pump or imminent

Norway Maple

doom, and adds a spice of excitement wholly irresistible to any child of spirit, which I pass on to anyone else who may have been told not to touch the fruit of yew because it's poisonous.

Personally, I have never got very far with eating beechmast, extracting oil from the fiddly little three-sided nuts or whatever else one should do. However, I realise that this ignorance is my loss because the liqueur, *Crème de Noyaū*, is made from young beech leaves.

Sycamore is one of the best trees for honey yield, especially valuable as it flowers early in summer. Stand on the lawn under our big sycamore when the seemingly insignificant clusters of little yellow flowers are blooming in May and you can hear the whole green dome of the tree above you murmuring with a thousand bees. If we are lucky in having this coincide with a spell of fine weather, we can see the result in the hives marked by a ring of honey recognisably olive-green in the comb. I know it is wrong to include sycamore and lime under indigenous trees, because the former is believed to have been introduced in Roman times, but, as anyone who has been blest with seedlings would agree, it certainly would appear to have established itself sufficiently well to be in no danger of dying out by not reproducing. I do so as I wish to stick up for 'weeds', albeit originally alien, which are strong and, because they have a good chance of survival, are more likely to be able to maintain a healthy ecological balance and contribute to our own survival as a species. Give me an armful of saplings out of the hedge before it is grubbed up by the bulldozer rather than aliens such as cupressus, sumachs and fatsias, favoured by the landscape contractors of today because their growth looks more striking in photographs for architectural journals.

Lime shares with sycamore the happy faculty of producing nectar-rich flowers for the bees later on in June but lacks the ability to reproduce itself with such abandon because the type commonly grown, *Tilia vulgaris,* is a hybrid between probably introduced Broad-leaved Lime, *T. platyphyllos,* and our own native species of Narrow-leaved Lime, *T. cordata.* This last type, once widely found in the Midlands, is to me the most interesting which I would grow if I lived within its natural distribution area. Twice I have visited a woodland reserve in Suffolk where it is still found: the first

27

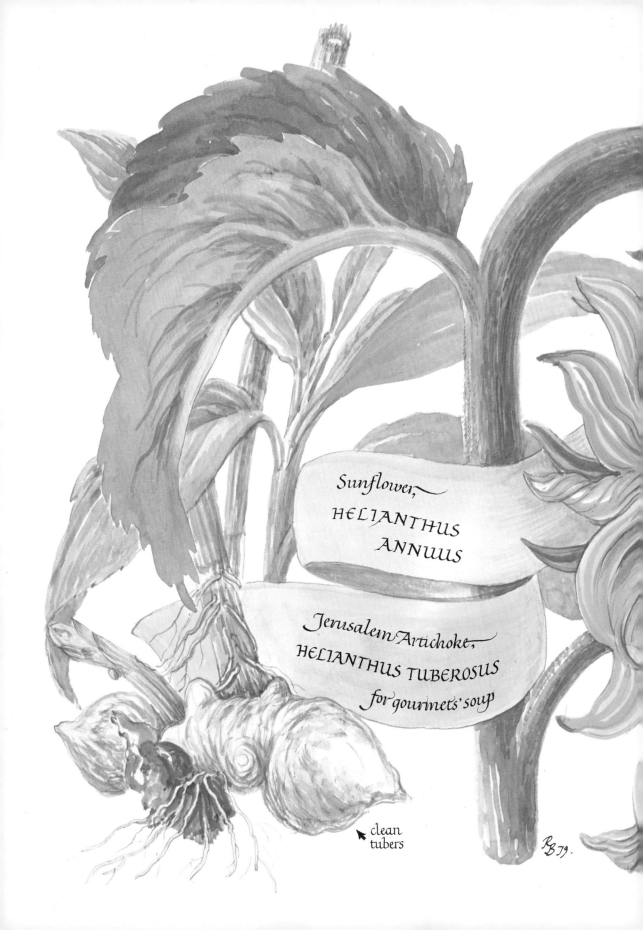

Sunflower,
HELIANTHUS
ANNUUS

Jerusalem Artichoke,
HELIANTHUS TUBEROSUS
for gourmets' soup

clean
tubers

RB 79.

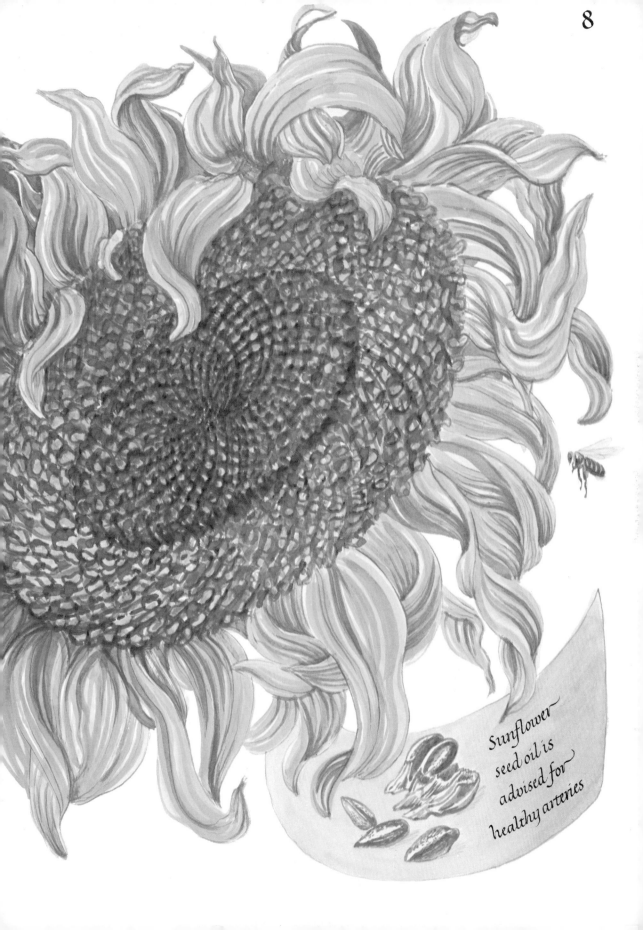

Sunflower
seed oil is
advised for
healthy arteries

time in summer, the woodland floor was sprinkled with rare Violet Hel-leborines and Herb Paris; the second time, in autumn, we found many unusual fungi, including *Helvella crispa*, a pewter-grey growth so strangely twisted it looks as if it had been invented by some Art Nouveau illustrator. It is believed to be the only remaining bit of indigenous natural woodland of its type in the county, undisturbed since prehistoric times, so it gives some idea of the riches we have thrown away.

Lime is a long-lived tree producing, besides its flowers used for making a delicious fragrant tea, fine-grained wood used by mediaeval carvers and musical instrument makers: Grinling Gibbons comes to mind immedi-ately but one wonders if he got his raw material from abroad, because the tree takes five hundred years to reach maturity and lime only began to be grown popularly as an ornamental tree in Gibbons' own seventeenth century.

Sycamore 'propellers'

To make lime tea, simply gather flowers dangling from low branches on their little 'aeroplane propellers' which later will whirl the seeds away on the wing. The bees will tell you when the lime flowers are ready to pick and it doesn't matter if you have seeds and propellers in too. Dry them on a tray and store in a jar, using a good pinch at a time in boiling water like ordinary tea.

When you think of it, it's really an odd accident of history that an island on the North Atlantic seaboard should claim as its national drink the leaves of India and China. Abroad, if one excepts the similar craving for the coffee beans of Brazil, people are more open-minded when it comes to tea.

Vervain, *Verbena officinalis* L., is quite popular. The plant is a wiry little labiate of dry ground in the south of England which would settle on any rockery as you hardly notice the small purple flower. The plant has been considered a remedy for almost every ill since the days of Hippocrates but I just happen to like it as a change.

We prefer mint tea, the popular French *thé menthe,* after dinner. *Mentha piperita* L., a hybrid between Water Mint and Spearmint is usually used but I daresay several of the others could be substituted and blended to taste as with tea and coffee.

While lime, verbena and peppermint teas are for everyday use, Chamomile or Feverfew, *Chrysanthemum parthenium* (L.) Bernhardi, is a sedative and its taste is such that I think of it as 'motorway tea'. I grow the attractive little daisy plants all over the garden, so I always have seedlings to give away, but I only use it for its medicinal qualities.

Mints tend to be another casualty of the tidy modern garden because they are stoloniferous and run about, rooting wherever the shoots touch down. In a cottage-garden hedge this never mattered but, if space is at a premium and one wants to keep some control, plant mint within the rim of an old bottomless bucket. At Dalgairn, mint colonises the heaps of rubble and broken glass in former cold frames, it likes lime and good drainage so, when no-one wanted the glass of ruined greenhouses, it seemed sensible to stack the panes upright in the brick bases under leaf-mould to provide raised beds for herbs.

Largest and strongest is Horse-mint, *Mentha longifolia* (L.) Hudson which will grow happily in rough grass and is distinguished by white woolly undersides to its leaves. Spearmint, *M. spicata* L., is the one used in chewing-gum and is usually grown in gardens.

Apple Mint, *M. rotundifolia* (L.) Hudson, is my wife's favourite for mint jelly. It seems to have plenty of little side shoots late in the year to go with windfall apples. Cut the rotten bits from the apples, cover in water and simmer till soft. Hang up in a jelly bag to strain off the juice. Boil your apple juice, adding sugar at the rate of a pound to a pint. Stir till it begins to set and add plenty of chopped green mint. Cool a while and fill little jars of a convenient size to get through with a single joint of mutton.

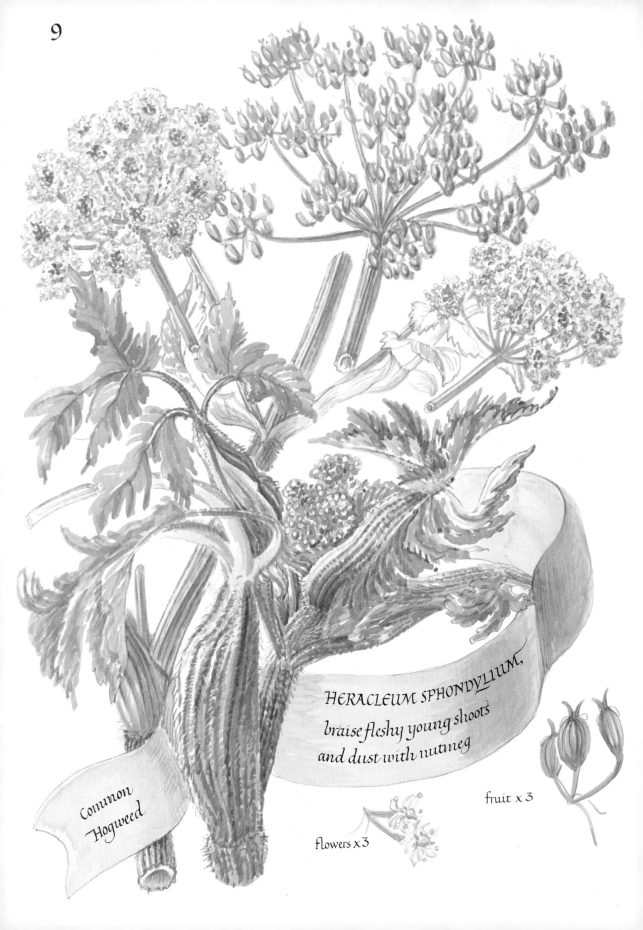

HERACLEUM SPHONDYLIUM,
*braise fleshy young shoots
and dust with nutmeg*

Common
Hogweed

flowers x 3

fruit x 3

At its best, traditional British food is unbeatable as the French realise perfectly well in trying to keep out our lamb. Our farmers produce the meat and the Devil sends the cooks; meat usually overcooked, never a bit of garlic slipped into the bone of the lamb, and, final abomination, mint sauce. Nowadays, when the time and effort of chopping by hand has been saved by a quick whizz in the liquidiser, and mint sauce is simply plenty of fresh chopped mint, a little sugar and vinegar, there is no excuse for restaurants serving mint sauce with what appear to be a few old tea leaves floating in a jug of vinegar. Better by far, than to pay for such disgusting rubbish, is to pick a few shoots of Water Mint, *M. aquatica* L., unmistakable by its smell when you stumble over it on a country walk over damp ground.

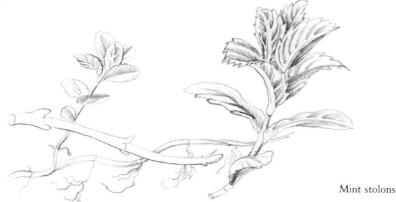

Mint stolons

As we had such huge rubbish dumps around the walled garden, everywhere there had been ruined greenhouses, abandoned cold frames and the general unsightliness of dereliction, my wife naturally wanted to cover it up quickly so sunflowers and squashes immediately suggested themselves.

A few sunflowers are always worth growing for the sheer Jack's Bean-stalk incredibility of the things. Books don't advise this as a plant for small gardens but, surely, it is the exact opposite which holds true? If your garden is encompassed by a few bricks and a backyard wall, provided it has a bit of sun, to have a sunflower growing up to twelve feet high will give the

most miraculous return on a few seeds. One can so easily understand the amazement with which the first Sunflower *Helianthus annuus,* was seen by the Elizabethans. In 1569 John Frampton noted 'the middle part as it were of unshorn velvet' and went on to liken the seedhead to 'a honeycomb of bees'. Before then, the Incas of Peru had a similar sense of wonder at such a plant, introduced to them from north-west America. They noted how the great capitulum, or disc of myriad flowers, twists daily to follow the sun, probably because the shaded side of the stalk grows more quickly, and acknowledged the flower as a sacred emblem of the Sun God. On a practical level the seeds, if pressed, are rich in oil and even just raw and salted, make the familiar Russian cocktail nibbles. Geese relish the leaves of the finished plant and the huge stems are used in paper making. What more can we ask of a plant? Isn't it a pity that, when Van Gogh should have been so fascinated by sunflowers and the greenery-yallery designers of the eighteen-nineties have seen such artistic potential in it, that we should be so blind to its majesty?

Many gardeners won't grow trailing marrows nowadays because they get so out of control. As it is in their nature to ramp, it seemed to me more reasonable to turn this habit to advantage and use them decoratively like vines. Nothing will lend your garden a more Rococo air of abandon in the golden warmth of late summer than the huge yellowing leaves and ripening fruit of the whole family of vegetable marrows, pumpkins, melons, squashes and gourds. Look at the pastoral frescoes of the younger Tiepolo and you'll see what I mean; Giandomenico not his uncle Giambatista – the fruitiest of marrows can hardly be expected to introduce succulent Venetian nymphs riding on a cloud in your garden. As far as growing outside in our treacherous climate will allow, pumpkins, together with marrows and egg plants are for me a 'must'. Running all over the Suffolk middens with such generosity to produce monster fruits, orange, green, yellow and lustrous purple, they were part of my childhood so I was saddened to find that, though all grown to perfection in the local College of Agriculture because they were part of the syllabus, nobody wanted to eat the end products. It was the sort of thing that constantly reminds one of the gastronomic poverty of the Scots.

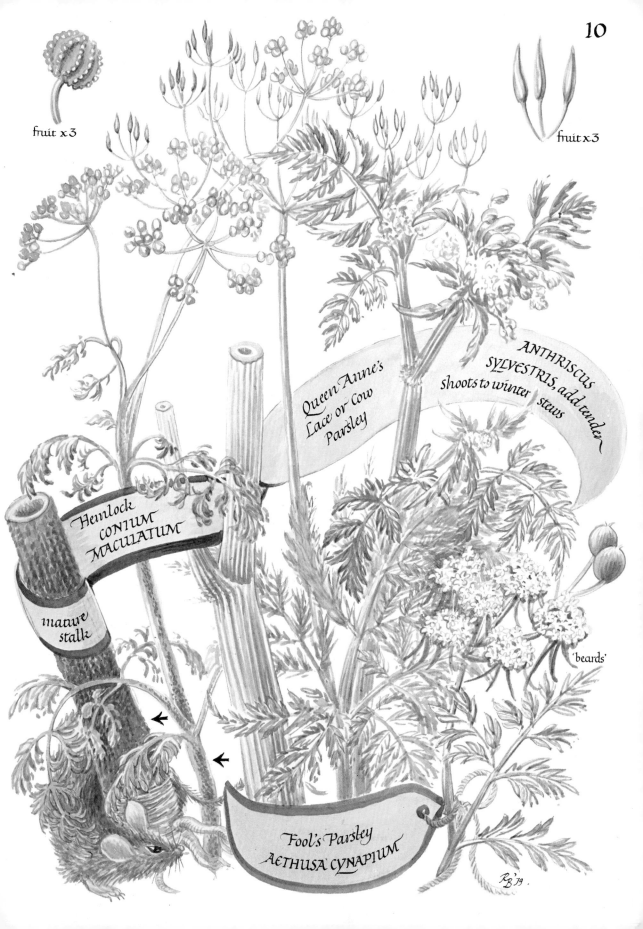

fruit x3

fruit x3

Queen Anne's
Lace or Cow
Parsley

ANTHRISCUS
SYLVESTRIS, add tender
shoots to winter stews

Hemlock
CONIUM
MACULATUM

mature
stalk

'beards'

Fool's Parsley
AETHUSA CYNAPIUM

RB '79.

My own liking for the marrows and pumpkins is more than confirmed by my latest Thompson and Morgan catalogue and I cannot do better than quote what they say:

> In China the pumpkin is the symbol of fruitfulness and is called the Emperor of the Garden. However, the Anatolian Turk, the Hungarian gypsy and the mountain-dwelling Bulgarians all knew that pumpkin nuts preserved the prostate gland and thus male potency.

So now we know.

They go on with technical stuff about phosphorus, iron and Vitamin B but the combined prowess of Turk, Hungarian and Bulgar is enough for me. Let's forget the rest. For my wife and me the annual saga of the marrow family is pure pleasure from the first tiny courgettes browned in butter, through the herby green interiors of stuffed marrows and ratatouille to stuffed marrow rings for the deep-freeze and marrow ginger when the late summer abundance swamps even our eating capabilities. Anyone who finds marrow 'woolly' has either picked it too late or cooked it too long. To others who complain that the texture of marrow ginger is less than perfect, I recommend the addition of a tin of pineapple chunks and a quarter of crystallised ginger, both diced to make them go as far as possible with plenty of lemon to offset the sweetness. This extravagance is justified if you make double the quantity you need and put half in your Christmas presents cupboard.

The secret of those Italian fritters that you can make of marrow flowers that are obviously never going to achieve fruition when frosts are imminent is, as I was shown by a Venetian friend's old cook, to drain them one by one on absorbent paper for half an hour in a warm oven so they remain individually crisp and never degenerate into a fatty mess. You can eat the tendril tips and buds too as a vegetable and the final giant pumpkin, usually cornered by a floral art lady for her arrangement by the font for Harvest Festival, will feed forty after she's finished with it.

My wife and I don't care much for sweet food. So pumpkin pie is out. To me the whole point of cooking something mild-flavoured and watery in texture like a marrow or pumpkin is to absorb the richer savoury flavours

of meat, onion, cheese and tomato; I'd never think of making it sweet and stodgy with pastry, so it is as well to know one's limitations.

The best recipe I know is an old Cape Dutch one for pumpkin bredy. Don't ask me if I've spelt it right because I have never seen it written, but that's what you call it. Peel and cut up your pumpkin, keeping the seeds for next year because you can seldom buy them. Pack it in your biggest pot, the sort of iron cauldron that hung on the back of the covered wagon if you can find one not in a Folk Museum, with meat of poor quality, onion and any rotten vegetables you can find: scrag end of mutton is ideal and those trays of soft tomatoes that greengrocers throw out for the dustman on Saturdays. Be generous with herbs and seasoning, adding a good shake of turmeric; that is the only vital bit. Cover with water and cook all day. Your nose will tell you when your bredy is done, as it all cooks down to a glorious sludge. Not the thing for a smart dinner party but spicy, herby and filling for a family.

Obviously you are meant to be the strong silent type, a monosyllabic Boer named after an Old Testament prophet, toiling all day out on the Veldt. It's that sort of dish, to be eaten with crusty brown bread after honest toil but to tell the truth, our pumpkin bredy always used to go a bit wide of the mark whenever we did it in London. No sooner did a delicious savoury smell begin to emanate from the kitchen when, like a garbled Cinderella story, up would pop the Prince. We knew our neighbour was hard up as he'd lost his estates behind the Iron Curtain and needed feeding but he always dropped in, as if by magic, whenever there was pumpkin bredy. Obviously he thought it was our staple diet: to see this elderly Ruritanian dipping elegantly into our witch's cauldron to pull out old mutton bones, bits of gristle and stomach lining while he talked of Life at Court in St Petersburg and Vienna was almost too much for our self-control and has made us apprehensive of pumpkins' powers ever since.

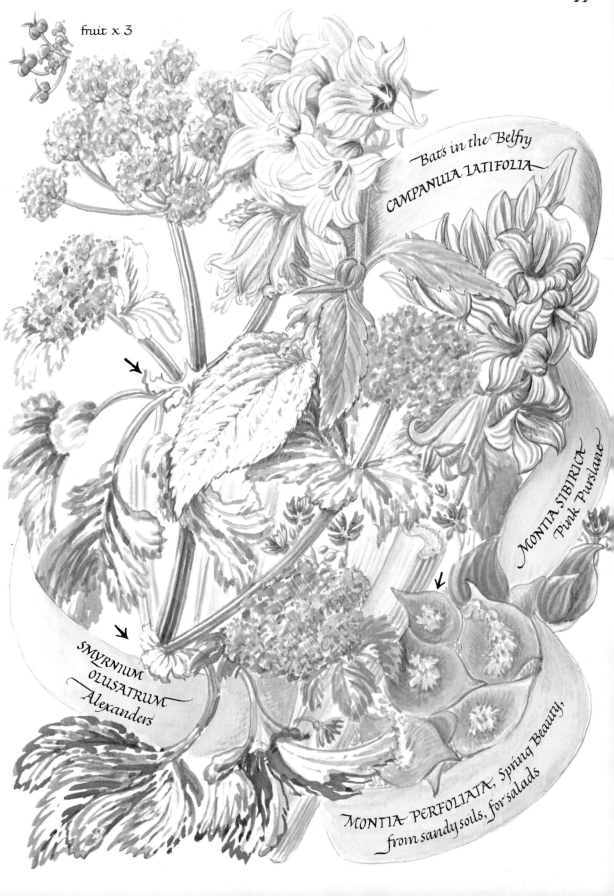

fruit x 3

Bats in the Belfry
CAMPANULA LATIFOLIA

MONTIA SIBIRICA
Pink Purslane

SMYRNIUM
OLUSATRUM
Alexanders

MONTIA PERFOLIATA, Spring Beauty,
from sandy soils, for salads

I am going to put Jerusalem artichokes here as another unfashionable vegetable, considered difficult or too big for garden subjects, because that is how most conventional gardeners now regard them. You'll get blank looks if you ask for them in most garden shops.

'Oh yes, sir, I know what you mean but we don't usually get asked for that sort of thing nowadays. There used to be an old chap who grew some on the allotments. If you'll give me time I could see what I can find . . .'

Behind you people are shuffling impatiently to buy plastic-wrapped dahlias and proper plants as advertised in bright catalogues, so you pass quickly on to carrots and onions, altogether safer ground. But don't give up the quest for Jerusalem artichokes. Watch out for a big sort of sunflower plant that never quite makes it, ending with a green tuft of little leaves instead of the usual Van Gogh postcard. Most people just throw them out so, because Jerusalem artichokes are very hardy, rubbish dumps often have a few. Look for them socially either at the top or the bottom; either down among corrugated iron shacks alongside the railway or on a first class pheasant shoot where a keeper who knows his job always puts down small plantings of them in the lee of the wood where the birds can scratch them out in a hard winter. I knew of an old Admiral who climbed over the wall to plant a sackful in Holland Park when it was out of bounds during the war, then he put down two or three brace of pheasants, not to shoot or supplement the meat ration, but just because it cheered him to hear the cocks squawking in the woodland before he went off to fight the Battle of the Atlantic, plotting convoys twenty-four hours on duty in the underground nerve centre of the Admiralty.

Jerusalem artichokes are unpopular in a tidy garden because of their rank growth but I think this is to be turned to advantage. If you use them like potatoes to clean the ground, there are all sorts of places where a quick growing temporary screen of foliage is of use to break the wind or to hide dustbins quickly while you are planning something more permanent.

Other people will tell you that Jerusalem artichokes are hard to prepare; this is because they have either bought them dried and shrivelled or left them about caked in mud for several days. Obviously these knobbly whiskered tubers hold the mud more than a potato so, like spuds, if you're

39

going to be the one who has to clean them, scullery-hand as well as gardener, grow them clean in the first place. Open your trench – nothing fancy needed – but put a shovelful of dead leaves and compost under each one as you plant it and a shovelful of sand/leaf-mould/sawdust on top and in six months you can dig them up as clean as if they had been packed for a supermarket. They'll certainly taste better because, as all the goodness and flavour is just under the skin, it's a waste to have to peel them.

Although it is more convenient to harvest artichokes in mild weather, they are hardier than potatoes and will stay in the ground through the coldest winter as an extra reserve of vegetables during the dearth of spring. Quite often, on the east coast, we have our worst weather at Easter. After weeks of crisp February sunshine, we settle down to day after day of driving sleet just when the first visitors make their appearance.

For the most perfect soup, a sort of poor man's Vichyssoise, clean as many Jerusalem artichokes and leeks as you have time for, boil until soft, liquidise, add a cube of chicken stock, seasoning and milk; simmer and serve with a blob of cream. Make a jam-panful, fill up the corners with bread and cheese, and a dozen to lunch unexpectedly on a snow-bound Sunday becomes a soluble problem.

For less extreme crises my wife often serves Jerusalem artichokes as a vegetable. Boiled like potatoes till they are just firm, then sliced, topped with grated cheese and popped under the grill, artichokes are very good hot, whereas the best of the little new tubers, steamed and served cold with parsley in a vinaigrette make a starter of unsuspected delicacy.

Jerusalem Artichoke, *Helianthus tuberosus,* 'was given the rather ridiculous name of Topinambour for no better reason than it was a curious-looking root from overseas and that it had arrived only just before some curious-looking savages of the Topinambour tribe who were brought to Paris and exhibited by one Claude Delaunay, Seigneur de Razilly, upon his return from a voyage of discovery to Brazil'.

The roots came from Massachusetts in 1607 but American geography was not a strong point in seventeenth century France and I quote André Simon's Encyclopaedia for unravelling this confusion of names. From France the roots reached Holland and they were cultivated at Ter Neusen

by Pastor Petrus Hondius who gave specimens to his friends abroad, including some in London, where the tubers first arrived under the name of Artschokappela van Ter Neusen, which soon became anglicised to Jerusalem Artichokes ... The name 'artichoke' is easily accounted for since the flavour of the cooked *Helianthus* is not unlike that of the Globe Artichoke, but the 'Jerusalem' is more puzzling. As the name 'Jerusalem Artichoke' in England for this vegetable was used long before the name 'Girasole' was applied to it in Italy, there can be no truth in 'Jerusalem' being an approximation of 'Girasole', which is the generally but wrongly accepted derivation of the name.

Oh, fie! Monsieur Simon. Holland is in the general direction of Italy and Jerusalem, so I don't suppose Shakespearian Londoners were too fussy about such matters and they did at least realise that *Helianthus* is a sunflower or 'Girasole'.

An Artichoke, *Cynara scolymus,* is really a thistle, which is why it has a 'choke' or flower-to-be, growing out of its base or 'fond', which is the best bit to eat; though I have seen girls in restaurants oblivious of this, with escorts too ignorant to scrape out the whiskery bits for them. The best variety to grow is *Gros Vert de Laon* which is deservedly popular, striking readily from heel cuttings and, as a cultivar, is outside the scope of this book.

Artichoke

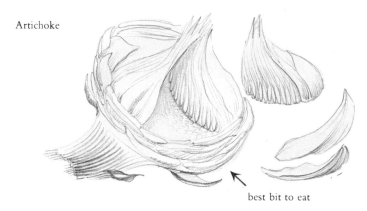

best bit to eat

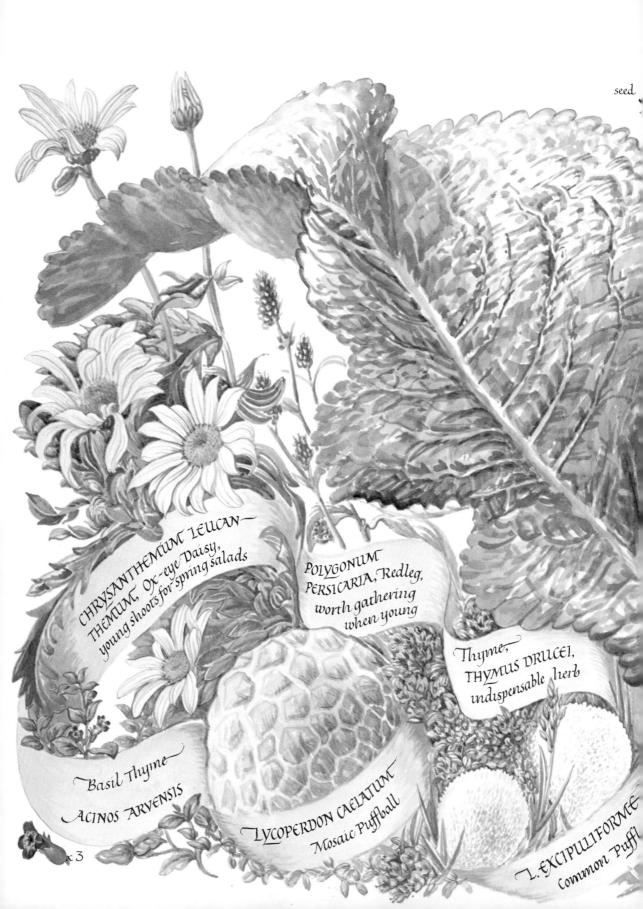

seed

CHRYSANTHEMUM LEUCAN—
THEMUM, Ox-eye Daisy,
young shoots for spring salads

POLYGONUM
PERSICARIA, Redleg,
worth gathering
when young

Thyme,
THYMUS DRUCEI,
indispensable herb

Basil Thyme

ACINOS ARVENSIS

LYCOPERDON CAELATUM
Mosaic Puffball

L. EXCIPULIFORME
Common Puff

× 3

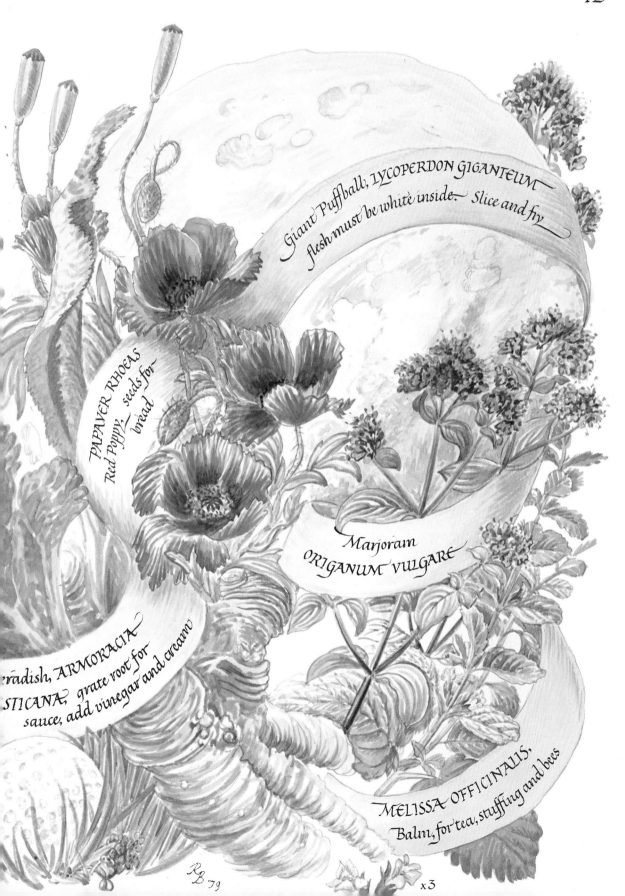

Giant Puffball, LYCOPERDON GIGANTEUM
flesh must be white inside. Slice and fry

PAPAVER RHOEAS
Red Poppy, seeds for
bread

Marjoram
ORIGANUM VULGARE

eradish, ARMORACIA
STICANA, grate root for
sauce, add vinegar and cream

MELISSA OFFICINALIS,
Balm, for tea, stuffing and bees

RB 79

x3

I have never seen a derelict garden which didn't have rhubarb. As a plant it would seem to be wellnigh indestructible; having been known to force its way through asphalt and even concrete slabs of new housing schemes laid down inadvertently over the rhubarb beds of old market gardens and allotments previously on the site. At Dalgairn we had lots, ranging from patches of thin-stalked, small-leafed bitter stuff, *Rumex alpinus*, the old Monks' Rhubarb of Scotland, quite all right for jam, to the most beautiful Champagne Rhubarb two inches across the stalk and so tender you can chew it raw. I see Percy Thrower tells us to 'Remove flower stems as soon as they appear' – with a picture of him doing it to such a mean little plant that I'd hardly have recognised it. Rhubarb is a greedy feeder of the midden but, for the lack of a steaming pile of horse manure, why not build your winter compost round the rhubarb? This saves trouble, the shoots will sprout through anything, a bit of wire-netting round will keep it tidy and, in summer, the spread of huge leaves will cover a sizeable heap. Your rhubarb will grow so strongly as a result that there will be enough to eat as well as plenty of flowers.

I had not realised, I admit, how fine these are. We never had them at home when I was a child – the gardener obviously went along with Percy Thrower. It was only when I tried to paint those six-foot spires cascading down in a foam of creamy blossoms, like lace, followed by huge rusty seedheads which endure for months, that I formed a proper appreciation of them. When London visitors constantly remarked how fine they looked and asked the name of such an exotic plant, I realised it was time that *Rheum rhaponticum* came off the dunghill, to be used decoratively at any odd corner where a strong vertical silhouette would look well and a temporary compost heap would not be inconvenient. Don't, by the way, let enthusiasm lead you into eating the leaves, however invitingly tender their spring green succulence, or you will be very ill indeed.

For those for whom rhubarb conjures a memory of what appeared to be stewed hair floating in pink slime, I commend Rødgrød – when faced with a Scandinavian name spelt with eggs crossed out, you pronounce it just as if you had a hot mouthful; make that desperate noise in the roof of your mouth somewhere between 'oo' and 'er' which signifies 'too-hot-to-

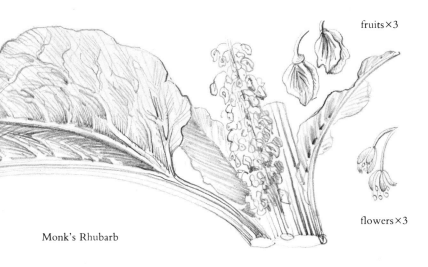

fruits×3

flowers×3

Monk's Rhubarb

swallow-but-too-polite-to-spit-it-out' and you've got it – Rødgrød: rhubarb thus liquidised and thickened to a jelly with a little cornflower becomes quite a different proposition, retaining the sharpness of rhubarb but losing that slimy consistency.

Best of all is rhubarb champagne. Whereas most home-made wines tend to cloying sweetness, we found that the use of Boots' Champagne Yeast and big flagons with lugs on so you could lash down the corks with wire to stop them blowing up, or rather blowing up in a minor fashion, was worthwhile. The key to the exercise was having a new plastic dustbin big enough to ferment the quantity we required. We made fifteen gallons and I used to tiptoe to the larder to see them straining at the lugs. In the event, none exploded and in six months they were ready to drink. As I looked at those fifteen jars of palest pink champagne fit for a Russian Grand Duke, I thought we had solved our drink problem. Alas! we knocked them off in three months of summer living even if they were a very good three months: four new dustbins and sixty gallon jars to get us round the calendar seemed excessive.

Obviously, in a large garden not maintained to the standard some people might wish, it is the larger plants which tend to survive. I don't mind this because plants of vigorous growth appeal to me more than frail little annuals on stalks like twiddly thread.

One of the most successful of all families of plants is *Umbelliferae*, those with flowers carried on little stalks or pedicels like the spokes of an umbrella. Because some of them are very good to eat and others are poisonous, it is important to be sure that you can identify one properly. Here lies the snag, because getting down to the details of botany tends to be boring: the exact classification of umbellifers is often determined by seedheads and that's a fat lot of use when you want to know whether you can pop juicy shoots into a casserole in spring. As with fungi, the answer in general must be 'Don't!' but, of course, just as anyone who has, with

45

practice, learned to recognise the different species and is to be trusted gathering mushrooms or some of the commoner fungi, so I remember having not the least difficulty at the age of ten in picking Hogweed, *Heracleum sphondylium* L., for my rabbit. Now I have painted its flowers unfolding from their curious bristly purse or petiole many times and know just where it grows along the hedgerow so have no hesitation about treating its tender shoots as a welcome vegetable.

The Giant Hogweed, *Heracleum mantegazzianum* Somm. & Lev., on the other hand, is poisonous. It is the largest plant to grow wild in Britain, often growing three or four yards high in a few weeks. Coming originally from the riverbanks of Siberia where obviously it has to turn the short Arctic summers to quick advantage, Giant Hogweed always makes news in the local press as 'Russian killer weed strikes again'.

I knew a fair-skinned garden enthusiast who developed a rash simply by walking past it but the best way to land yourself in hospital is to roll up your sleeves on a nice spring day when the sap is rising and set about cutting it down. Three-inch-long blisters will form on your forearm or wherever you have touched it and boys who have used its hollow stalks as pea-shooters have blistered internally as well. Far better to let it flower as a magnificent specimen for a shady corner of the garden and bestow the huge harmless seedhead on a dried-flower arranger as a Christmas present. Once you have learned to recognise the seedlings, unwelcome plants may be removed with a glove while still small.

Cow Parsley or Queen Anne's Lace, *Anthriscus sylvestris* (L.) Hoffman, is another welcome wild flower, easily recognisable to anybody once it covers the roadside with its elegant tracery of blossom in June. By then, alas, it is too tough to eat and there are plenty of alternatives anyhow. When one wants it is in March when it's tender and the prices of vegetables in shops are at their peak. Why not let a patch settle here and there in the garden? Then, when you know for sure that you've got the right species, treat it like celery in soups and stews.

Fatal species most liable to be confused with Cow Parsley are Fool's Parsley, *Aethusa cynapium* L., a greyish weed of arable land, to be distinguished by its 'beards' below the flower heads, and Hemlock, *Conium*

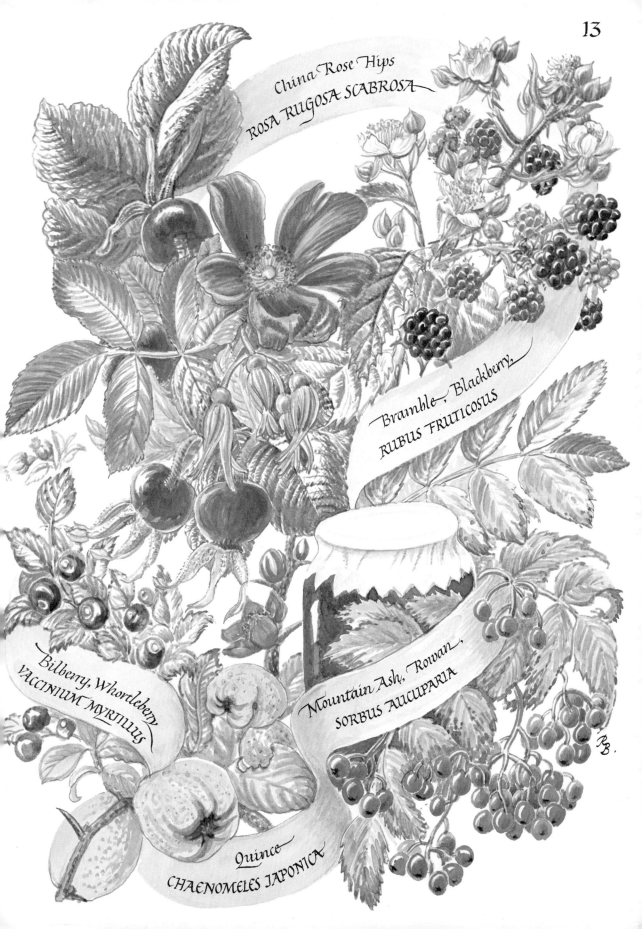

China Rose Hips
ROSA RUGOSA SCABROSA

Bramble, Blackberry,
RUBUS FRUTICOSUS

Bilberry, Whortleberry,
VACCINIUM MYRTILLUS

Mountain Ash, Rowan,
SORBUS AUCUPARIA

Quince
CHAENOMELES JAPONICA

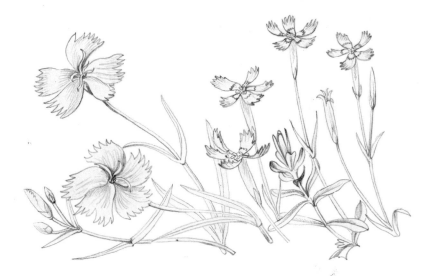

maculatum L., a magnificent feathery green foliage which I have noticed doing particularly well where people walk their children along the banks of the Thames at Richmond – 'when baby's cries grew hard to bear . . .'

Hemlock is a surprisingly common roadside weed. For anyone contemplating doom by a Socratean Cup, the identification points of this elegant plant are its round seedheads, purple spots developing on the stalk and a smell of mice about the root. Whereas it is easy enough to identify an old plant, young shoots right for cooking tend to look alike. That is why Alexanders, *Smyrnium olusatrum* L., delicious if braised like celery when young, is better identified when mature. It is our only yellow-flowered umbellifer with big dark-green glossy three-lobed leaves, common in hedge banks near the sea, so better really grown in a wild garden to be sure of gathering the right shoots properly tender in early spring.

Another recommended umbellifer is Sweet Cicely, *Myrrhis odorata,* which grows more commonly in hilly districts of Britain where its thick clusters of clotted-cream flowers appear in May with leaves more lush, yellow-green than those of Cow Parsley. Identification is clinched by a pinch of the leaf: a strong smell of aniseed reminds you of something? Sweet Cicely is one of the chief herbs of sub-alpine woodland used in making Chartreuse liqueur. Even if a private still is regrettably beyond our culinary capacities, there's no reason why Sweet Cicely shouldn't be added to fruit salads, drinks and sweetmeats. Moreover, the plant makes an excellent subject for a shady part of the garden if you gather seed from the inch-long upright seedheads in late summer. These tall seedheads, common by most roadsides in the glens are especially important to avoid confusion with those umbellifers which are poisonous. *Oenanthe* and *Aethusa* may sound like charming nymphs with which to dally by the stream but, as the Latin names of various water dropworts and Fool's Parsley, if eaten, they'll land you in the morgue.

Sweet Cicely seeds

In northern Britain, the Great Bellflower or Bats in the Belfry, *Campanula latifolia* L., grows strongly enough at the edge of some woodlands to add it to the list of spring vegetable shoots. Anyhow most old gardens have a few clumps in the border, so why not grow a few more and take a picking of it for the kitchen just to thin the blooming shoots in spring?

Pink Purslane was another little plant, only six inches high, which I found growing in the woods here in such profusion that, when it flowers in May, it gives an illusion of pink ground mist. People find it difficult to be sure of its identity because it is really an alien from America and many books give it under different names. *Montia sibirica* (L.) Howell, *Claytonia sibirica* L., *C. alsinoides* Sims is now its full title, including them all as result. It only arrived a hundred years ago but has already settled securely in the wetter parts of Britain which aren't too acid and cut off from easy distribution so, if you have it at all, you'll have enough to pick. February–March is not too early to go out in the wood gathering its pleasantly tangy shoots just when fresh material for salads is hard to come by.

Spring Beauty, *Montia perfoliata Willd.* is almost a twin species coming also from North America; one wonders how and why, as it is even smaller, with the odd characteristic of having its stalk growing through the middle of its little rounded leaves, hence 'perfoliata'. It, too, is good to eat and is more likely to be found in the drier south-east of England, having become even common in the sandy lanes round Aldeburgh, appearing long before any garden salad plants feel they can brave the east wind.

My mother taught me as a child that her favourite pinks and carnations like nothing better than the good drainage of old lime mortar: indeed, most of our native pinks such as the Deptford, *Dianthus armeria:* the Maiden, *D. deltoides* and the Cheddar, *D. gratianopolitanus*, are only to be found high in limestone cliffs and ruins where their needs are met and people can't get at them. Thus I realised what a waste it was, when we lived in London, to see those huge disposal skips full of rubble being taken away from some building job. I used to rummage through them, finding old bricks and stones with which to make retaining walls and, better still, bucketfuls of old mortar – the sort of things you have to pay pounds for in plastic bags at a garden centre.

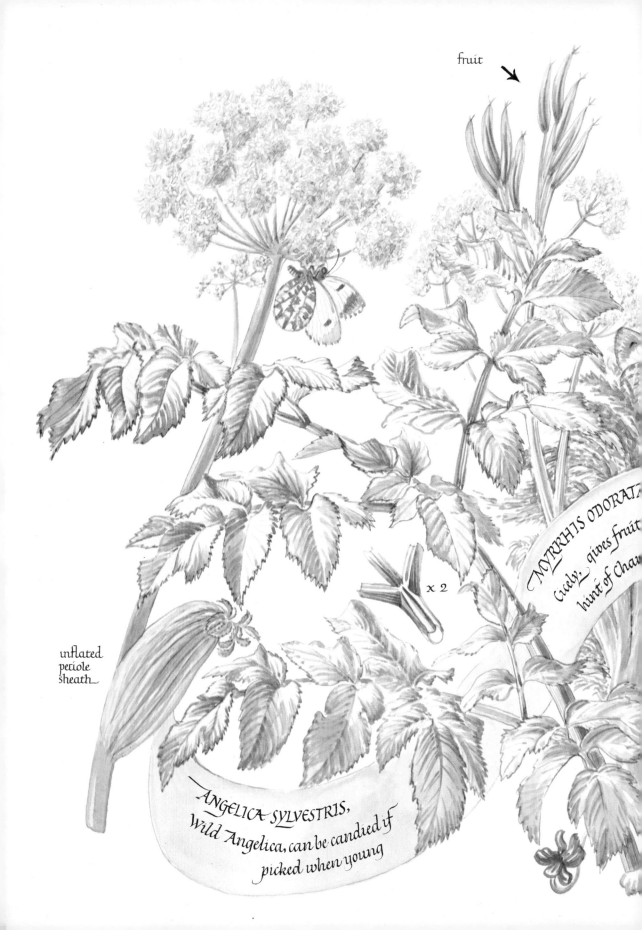

fruit

inflated
petiole
sheath

x 2

MYRRHIS ODORATA
Cicely, gives fruit
hint of Cham...

ANGELICA SYLVESTRIS,
Wild Angelica, can be candied if
picked when young

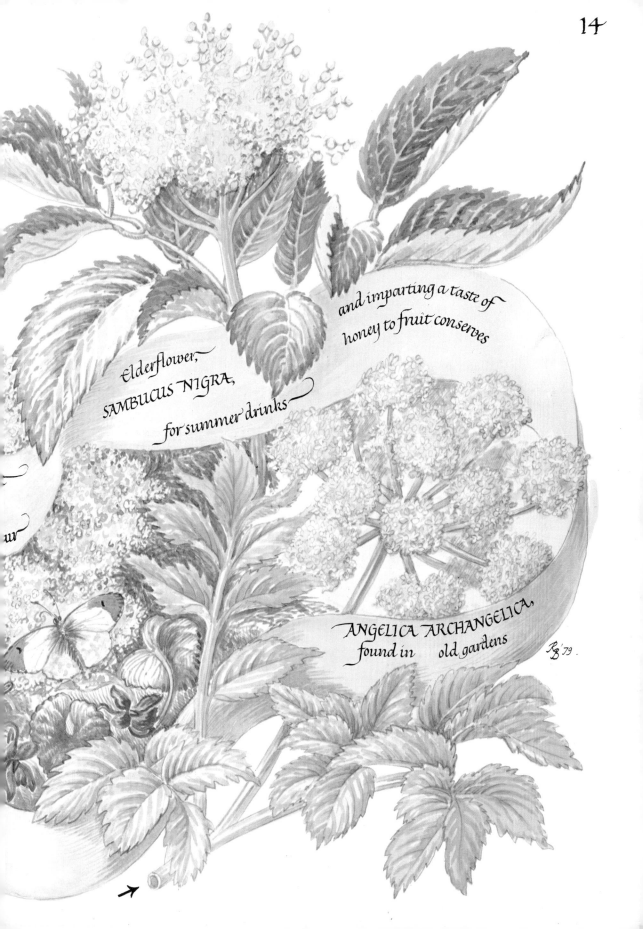

Elderflower,
SAMBUCUS NIGRA,
for summer drinks

and imparting a taste of
honey to fruit conserves

ANGELICA ARCHANGELICA,
found in old gardens

RG '79.

Living in a Wild Garden

Once you have your heap of lime rubble approximating to chalk down-land, you can grow any of the associated wild flowers. Invaluable in the kitchen are thymes, marjoram and balm. Our own creeping Wild Thyme, *Thymus drucei* Ronn., which gives downland turf its characteristic smell, will grow just as happily through the lawn or rock paths, making them a delight to walk on, if only they are sufficiently dry and limey. Marjoram, too, *Origanum vulgare* L., the oregano of a Mediterranean kitchen, is a common enough weed of our downland to bring into the garden. Let it loose as ground cover on a dry sunny bank to provide the basis of sufficient mixed herbs to carry you through even a Scotch winter.

Basil Thyme, *Acinos arvensis* (Lam) Dandy, on the other hand, is not the basilico sprinkled so liberally on Italian tomato salads which is, alas, half hardy and needs protection here. The prettily marked little violet and white flower of Basil Thyme is typical of the species declining most rapidly due to improved farming. Like yellow gentians, blackstonia, cudweeds, cow-wheats, pheasant's eye and a host of others, it needs primitive agriculture to survive; a shallow scratched furrow in the downland turf in which to set seed, safe from being choked by the rank grasses of improved pasture. Nowadays, these conditions are most often provided by the British Army. Botanists know well that, if you follow the tracks of tanks manoeuvring at speed on Salisbury Plain, you are likely to find many more rarities than can be given adequate sanctuary by the sort of pacifist conservationists who bleat in the literary weeklies.

Balm, *Melissa officinalis* L., is such an important bee-flower that it should be grown for that reason alone. A passing pinch of its lemony leaves shows its worth in the kitchen, marvellous for mixed herbs, stuffing, fish and chicken dishes as well as in tea. In hot weather my wife often mixes half Earl Grey's, and a sprig of Balm for really refreshing garden tea.

Others equally attractive and edible are poppies and ox-eye daisies, redleg and catmint.

With poppies you want the Common Reds, *Papaver rhoeas* L., with the round seedhead, or *P.dubium* L., with the longer one: just tip them upsidedown like dolls' pepper-pots when they are ripe and sere in autumn and shake the seed into an envelope for winter baking.

Papaver somniforum, L., with glaucous foliage and larger pinky-purple flowers is the Opium Poppy, common on sunny wasteland. To extract the drug, you have to scrape each green fruit daily, tear by tear, then cook it up and refine it which sounds too like hard work for my idea of opium – eating *dolce far niente.*

Can anything be more evocative of hot June days than Ox-eye Daisies? *Chrysanthemum leucanthemum* L., is the cumbrous Latin name and when they grow happily on any grassy bank it seems a pity not to let them. After flowering, the tidy-minded can scythe the dead growth and run the grass cutter over the patch in August without harming the plants. Once you can recognise their serrated leaf shoots you can spread the seedlings round. Any you don't want, you can eat either as vegetable or in salad. Indeed, I remember daisy shoots, because they were locally grown, as being the only salad leaves that one could afford to buy during March in a Zurich supermarket.

Redleg, like other closely related *Persicarias,* is edible. In the old days of free-ranging hens, they always took a peck of this and that as they scratched round the farmyard. Now, when they are imprisoned in air-controlled Belsens in the name of progress, and access for huge combined harvesters has made it necessary to remove the old farm gates, you will often find such a fine clean picking of *Persicaria* all unwanted. It seems a pity not to take some home to cook for your own supper. Pick tender shoots only. If such wild weeds are at all tough, shred from the stalk, boil lightly and liquidise to a purée.

Common Red Poppies Opium Poppy

Bistort, POLYGONUM
BISTORTA, for Cumberland
Easter puddings

Jack-by-the-hedge,
ALLIARIA PETIOLATA, an early
wayside vegetable

attractive
to moths
too

Wood Sorrel, Wild
Shamrock, OXALIS
ACETOSELLA, adds sharpness

Dame's Violet, Sweet Rocket,
HESPERIS MATRONALIS, scented
flowers and edible leaves

In the thirties when I was a child, though my mother tut-tutted over housekeeping bills, big joints of roast beef appeared on the table with unfailing regularity, usually accompanied by horseradish sauce. This is bite-tongue, hot and creamy, quite different from that sweet emulsified muck sold in bottles. To make it, choose a windy day and go outside to grate your roots of horseradish, because it makes you cry much worse than onions. Store it under vinegar in a covered jar then it will be always ready for use. Simply spoon out a sufficiency to blend with cream to taste. In the ample gardens of those days there was always a place where horseradish grew, usually in a half-forgotten corner of heavy ground which nobody ever quite got round to cleaning properly. We discovered ours down by the potting shed. Old gardeners of the 'dig everything up to clear the ground' school warn you about the horseradish in the garden. 'Yon's an awfu' dirty weed!' What they mean is that if you keep chopping at it with a spade, *Armoracia rusticana* propagates itself by root cuttings, whereas if you let it be in rough grass it will settle down quite amicably. It likes good drainage which is why it is to be found on embankments and sand-dunes and is thus a natural plant to grow on the heap of rubble one often finds after the builders have left.

Considered aesthetically, the leaves of horseradish are some of the most beautiful I know; up to two feet long, each arches from the central growth almost describing a semi-circle like a palm frond. It is V-shaped with a toothed fringe which grows so strongly from its central rib that it develops a rhythmic undulation, all dark green with well defined veins yet, because of this serpentine growth habit, the light can be seen alternately to shine through it and be reflected from it in the most subtle way. Horseradish is in fact a very common weed on railway banks: for years there's been a thriving colony in the triangle between Gloucester Road, South Kensington and Earls Court. Now I see that extortionate nurserymen are offering it at £5, which is the sort of thing which made me realise I had to write this book for an urban populace brain-washed into accepting tasteless if not actually dangerous processed foods – cancer of the lower bowel is now officially linked to insufficient roughage in our diet and even for those with gardens, it is cheaper to grow mass-produced alien cultivars than our own natural heritage of useful cottage plants.

Living in a Wild Garden

Willow wren
in old
gooseberries

Other blessings we discovered in a derelict part of our garden were old blackcurrants and gooseberry bushes, not to mention elder saplings. The first two were, we were told, only fit for burning: the blackcurrants had big bud, an incurable disease, and the only way to grow gooseberries is to plant *new* varieties in a fruit cage because of the birds. Closer inspection revealed that, in fact, the birds were doing very nicely with nests of willow wrens in the gooseberries, of robin, blackbird and thrush in the larger fruit bushes so I did nothing. In due course, even the wildest and most ancient of gooseberries puts out a few hard green berries. 'No good for anything – not even cooking' said those with memories of endless 'top and tailing' in the cause of acid puddings and jam made apparently of leathery husks. By making gooseberry jelly, all this labour is made unnecessary and a few sprigs of elderflower flung into the jelly bag transforms the result into a suggestion of muscat grapes, perfect for serving with meat.

As for blackcurrant, we can always buy blackcurrants from people who haven't willow wrens and, anyhow, the leaves are more important than the fruit to my wife who uses them to make the most delicate of water ices. I had really forgotten about the big bud until I found, on re-reading Audrey Wynne Hatfield, that she cured hers by compost of stinging nettles. Of course, I have nettles surging all over mine to make cover for the birds so no wonder the dreaded disease was defeated by a happy ecological equilibrium.

Elder grows everywhere even in places as seemingly unfavourable as the docks and wherever daylight penetrates the London Underground system and the virtues of its creamy flower clusters cannot be extolled too highly.

Elderflower syrup is such a useful adjunct to fruit salads etc that my wife deep-freezes it to ensure a constant supply throughout the year. Pick plenty and strip the flowers from the umbel stalks with a fork. Boil, strain, add sugar or sweetener to taste and freeze in the ice-cube compartment. When frozen solid turn out the cubes, each now handy-sized for use and store in a plastic bag. Elderflower wine is one of the best whether still or made into a sweet champagne-type. Elderberries, on the other hand, though they too can be used to make a heavier port-type wine – remember 'Arsenic and Old Lace'? – are slightly laxative, an attribute of the fruit or of the jam or jelly which I have known turned to good use in the nursery.

Damsons were indispensable to the old-fashioned cottage garden. Damson, *Prunus domestica* L., an orchard tree, because it is a natural species, layers happily from its own roots and grows up true to form so needs only a sharp spade to sever its parental attachment when you want to move or give away the young trees. For those with tart palates, damson jam is one of the best, though the stones can be a nuisance unless you have plenty of child labour to sit, as I did, with a hammer on the steps cracking the boiled stones to extract the kernels for peeling and adding to the jam.

Many people find that, once they have stopped having children home for tea, they don't eat jam. I remember, for a large family, hundredweight sacks of preserving sugar, washing jam pots by the box, Kilner jars by the dozen for bottling fruit and Mrs Bush our cook presiding over huge copper jam-pans holding forty or fifty pounds at a go which Bushy had to come in and help lift off the stove. When the war brought blitz and buzz-bombs, my parents used to sleep in the basement larder. Each near explosion made hundreds of jam pots all round jump a little nearer the edge of the shelves and a direct hit would have interred my poor parents, indistinguishable from bottled fruit and jam.

My wife makes jelly because it's so much easier. Cover the fruit with water and boil till tender; hang it in a bag to drip through overnight, resisting any temptation to squeeze the bag or your jelly will be cloudy. Next day cook up the liquid, adding a pound of sugar to a pint of juice or pulp and stirring constantly to prevent burning on the bottom. Any difficulty with jam or jelly setting can be avoided by adding lemon juice

and the pips of lemon tied up in a muslin bag to raise the pectin content.

The pulp remaining in the bag may be forced through a sieve and cooked up with sugar too, exercising even more care lest it burn. Pour the resultant toffee-like pulp into shallow baking trays and dry it. About six weeks on a storage heater is enough and takes you nicely up to Christmas. Cut the damson cheese out of the tray in neat sections, dusting each with icing sugar so that you have sweetmeats for the table or to give away as presents.

Made from quince, cheese is especially good and a celebrated delicacy in Spain, '*Dolce de Membrillo*'. I find that to go round the housing estates, knocking on the doors and offering to pick up the windfalls of *Cydonia japonica* (or *Chaenomeles* as we must now learn to call it) is the best way of getting quinces in the north. People plant it for its coral blossom in spring and find it hard to believe how good the little yellow fruits are even when you take them a pot of quince jelly in return.

Rose hips are all good for jelly making. We favour the old China Roses, *Rosa rugosa* which have a sub-species, *scabrosa* (I always want to call it sub rosa) with hips as big as small tomatoes.

Bramble or Blackberries, *Rubus fruticosus* L., has many varieties but all go well with windfallen apples to make jelly. They are much better picked by children because the odd unripe fruit goes in to sharpen the flavour: grown-ups pick with a too uniform selection.

Better still, are Bilberries, *Vaccinium myrtillus*, L., Whortleberries on the Yorkshire moors, American Blueberries, Scottish Blaeberries where, alas, though so common, they are hardest to pick in quantity because grouse feed on them first.

Rowan, *Sorbus aucuparia* L., remains, I think, my favourite because its sharp tang goes so well with game of all sorts and offsets the greasiness of roast lamb and poultry.

Shred the rowanberries off the stalk with a fork and add to windfall apples as with other jellies and, if a windswept moor isn't handy to gather them wild, *Sorbus* species as Mountain Ash have made themselves so popular in suburban roads where their small neat growth makes them ideal that you can always pluck a few without vandalising the neighbourhood.

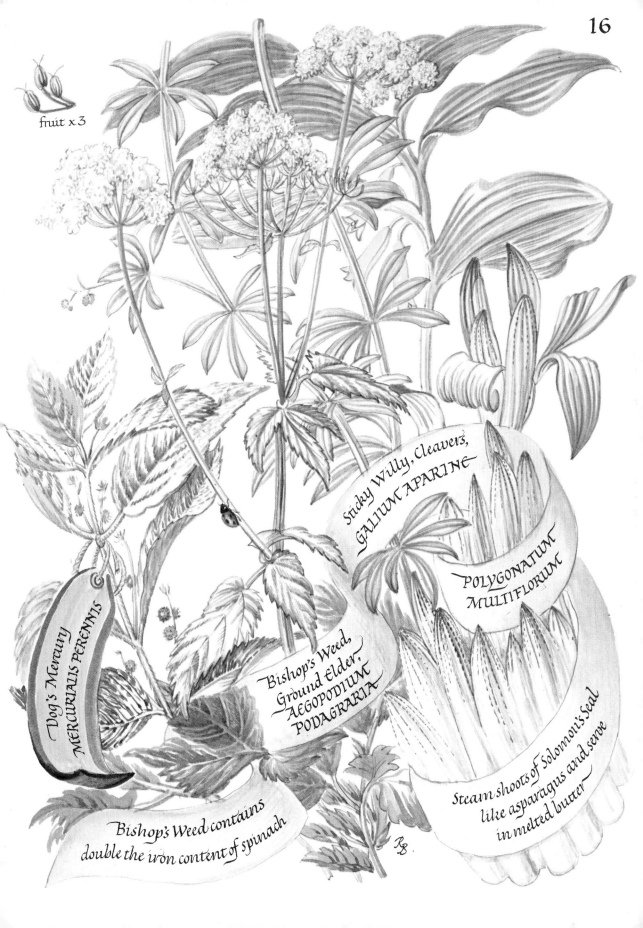

fruit x 3

Dog's Mercury
MERCURIALIS PERENNIS

Sticky Willy, Cleavers,
GALIUM APARINE

POLYGONATUM
MULTIFLORUM

Bishop's Weed,
Ground Elder,
AEGOPODIUM
PODAGRARIA

Bishop's Weed contains
double the iron content of spinach

Steam shoots of Solomon's Seal
like asparagus and serve
in melted butter

Living in a Wild Garden

Honesty flowers

Angelica archangelica is a plant as fine as its name. I found it in the garden of a deserted cottage and was immediately struck by its impressive branching growth and tiers of celery-crisp leaves rising to pale green umbels of flowers. I left it for a couple of months then went back for seed. In addition there were the odd seedlings already rooted round about the parent plant which was lucky because Angelica is monocarpic, or biennial, as it used to be termed, producing flowers next year on this year's seedlings then dying, so that one has to have plants on alternating cycles leap-frogging, as it were, to keep up a constant supply.

Stalks of medium thickness are best to candy as the little ones have insufficient body and the big ones tend to be tough. One good-sized plant and an afternoon fiddling about between a sticky saucepan of syrup and the drying rack with lots of tasting and finger-licking will result in enough candied angelica to cover all cakes in the foreseeable future or provide a most acceptable offering for the next 'bring and buy' stall. You'll see why if you care to ask the price of a stick in the grocer's, and if you really want to achieve that shrill green colour instead of the natural golden green add colourant to the syrup you simmer them in.

Our own Wild Angelica, *A. sylvestris* L., more common throughout the wetter hilly districts of Britain, is not quite so good to eat, being more liable to be tough; but then the ability to grow in a wet wood a day's drive beyond the nearest proper grocer's shop makes up for it. You identify it by

Honesty seedheads

its rounded pinky flower heads, well branched leaf stalks grooved on top and unmistakable smell of aniseed. If you are happy with this taste in a savoury context, you can cook the foliage as a vegetable, no more odd than the German taste for putting caraway seed in cabbage.

Jack-by-the-hedge, *Alliaria petiolata* (Bieb) Cavara & Grande, which some call Garlic Mustard, is another excellent salad plant to be found in sheltered corners in earliest spring. Like Dame's Violet, *Hesperis matronalis* L., another crucifer, also good to eat, it makes a charming subject for the garden, producing drifts of white candytuft-like flowers in early summer. In fact, I like Dame's Violet too much to eat it and can never have too many of its scented blooms, especially attractive to moths, growing all over the place. Both species are monocarpic so one always has to be on the look-out for odd groups of seedlings where you don't want them, to plant out in places where you do. A third similar species, *Lunaria*, Honesty, is also known as Money-flower because of the shape of its seedheads, first green, then yellow, then dun. If you rub these discs, when quite dry, gently between your fingers, the drab outer husks will come away with the seed to be shaken out for next year, leaving you with a branch of silvery inner discs like fairy tambourines for Christmas, altogether one of the most satisfactory of all cottage plants.

Wood Sorrel, *Oxalis acetosella* L., is a woodland species which you can eat, common throughout Britain except in the flat heavy ploughed lands

PETASITES FRAGRANS, scented
Winter-Heliotrope

CHENOPODIUM BONUS-HENRICUS, Good
King Henry, pre-historic spinach

MYCELIS MURALIS,
Lamb's Lettuce

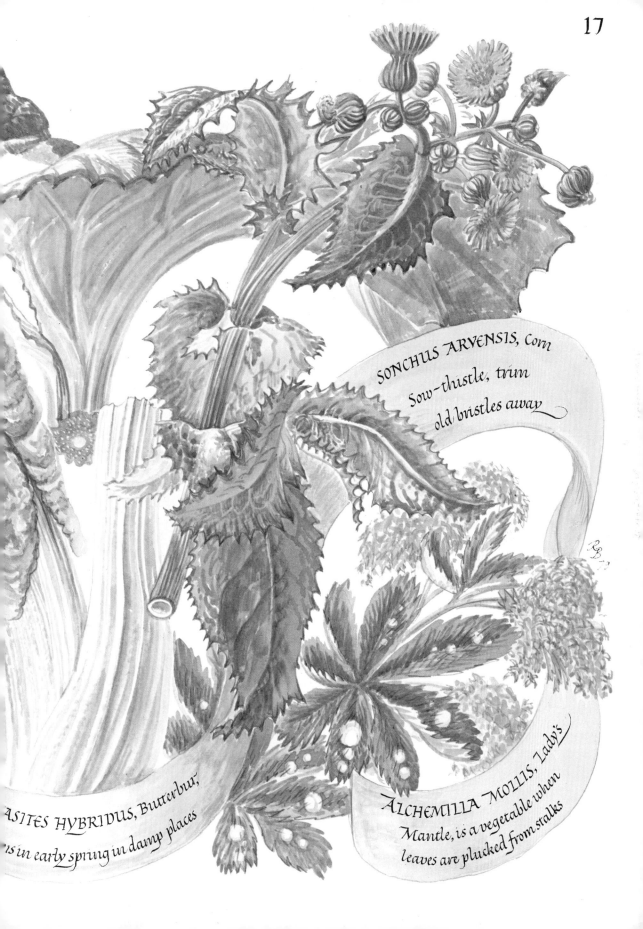

SONCHUS ARVENSIS, Corn Sow-thistle, trim old bristles away

ASITES HYBRIDUS, Butterbur, is in early spring in damp places

ALCHEMILLA MOLLIS, Lady's Mantle, is a vegetable when leaves are plucked from stalks

about The Wash. I always pick a leaf or two for visiting children in the spring because it is so strongly anti-scorbutic that it tastes recognisably of lemon but otherwise I let it be, preferring to enjoy the extreme delicacy of its white bell flowers and shamrock leaves, borne on red thread-like stalks from a creeping central rhizome which also has flushed coral nodules. Because it loves to grow in damp half-shade, *Oxalis* is far more likely to have been the original shamrock of Ireland, rather than any of the clover family, for the simple reason that the latter prefer the open drier country of East Anglia and in Scotland, it is fitting that in the woods along the shores of the Solway Firth, the nearest to Ireland you can get, an attractive rosy pink form should be found.

Bistort, *Polygonum bistorta* L., sometimes called Snakeweed, a larger relation of little Redleg and Solomon's Seal, *Polygonatum multiflorum* (L.) All. seem to go together in semi-shady situations of a woodland garden.

Bistort has flowers like a little brush on stalks two or three feet high and its leaves were formerly used for Cumberland Easter puddings. Personally, I find that, though an attractive plant to grow, it tastes no better than dried stuffing out of a packet so prefer to leave puddings alone and merely to throw a few leaves into the general vegetable basket in passing.

On the other hand, Solomon's Seal . . . 'You'd eat my Solomon's Seal?' – Already I sense the rising fury of the lady gardener defending her precious rockery. 'No Madam, I shouldn't dream of touching your measly little bit of solomon's seal in a south of England garden!'

Up here it grows wild where partial shade prevents the woodland floor drying out and in any old garden where people aren't forever 'tidying' the top soil into barren dust bowls. As I have to clear paths through a tangle of shrub roses and lush clumps of Solomon's Seal containing their spread I watch for buds. Snapped off in spring like asparagus when it is no more than a few inches tall and steamed lightly in the same way, Solomon's Seal is delicious, served either hot with melted butter or to accompany egg dishes or cold with a vinaigrette or hors d'oeuvres. Even if the plant grows in a more sunny place only cover its fleshy roots in barrowloads of leaf-mould, respecting that Solomon's Seal is a wood lily and you can cut and come again and still have plenty of elegantly tiered foliage remaining.

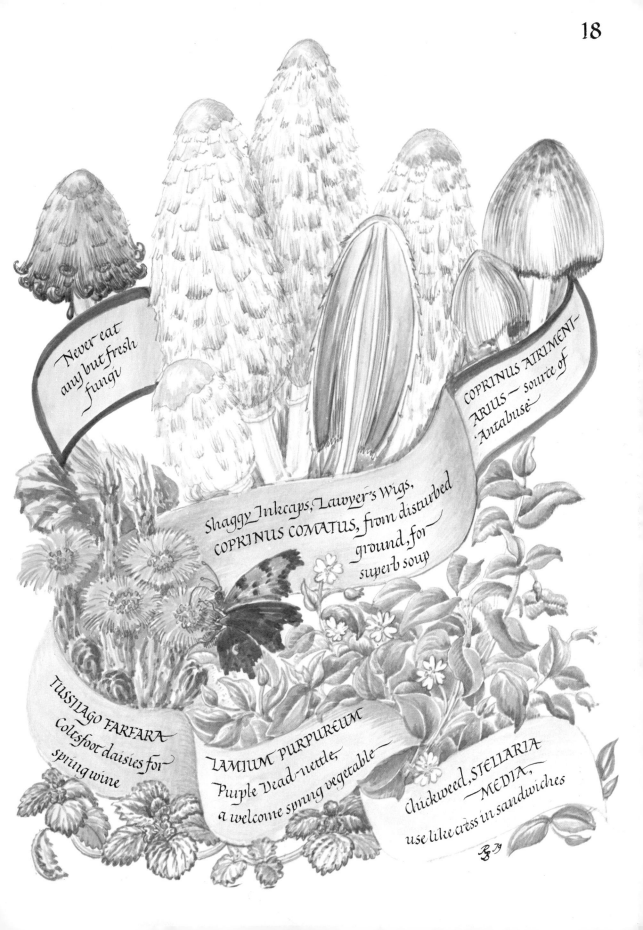

Never eat any but fresh fungi

COPRINUS ATRIMENT-ARIUS — source of 'Antabuse'

Shaggy Inkcaps, Lawyer's Wigs, COPRINUS COMATUS, from disturbed ground, for superb soup

TUSSILAGO FARFARA Coltsfoot daisies for spring wine

LAMIUM PURPUREUM Purple Dead-nettle, a welcome spring vegetable

Chickweed, STELLARIA MEDIA, use like cress in sandwiches

Another spring vegetable is *Alchemilla mollis*, that stand-by of flower arrangers. Strip off the leaves of Lady's Mantle, and boil them in a little water for ten minutes.

Sticky Willy, Goose Grass or Cleavers, *Galium aparine* L., with tiered leaves and rather weak rambling growth, weak, that is till it's hooked onto your clothing when it clings tenaciously by barbed bristles, might not suggest itself as edible. Wind it round your arm like a hank of wool and coil it down into boiling water like spaghetti and it will be quite docile. You can eat tender shoots entire but if, probably, the bit you've got is too tough to be appetising, throw it away after a few minutes' boiling like any other tough leaves but make the juice the basis of slimmer's consommé.

Cleavers

Because it is so good to eat, with double the iron content of spinach, I am including Bishop's Weed *Aegopodium podagraria* L. This species, which gardeners work so hard to eradicate, is known variously as Gout-weed, Bishop's Weed or Ground Elder, because it was handed round the monasteries of the early Church as a specific medicine against the agues resulting from such Spartan conditions, and although Puritans were happy to throw out the Church, they weren't prepared to give up such a beneficial source of food, so it had to change its name.

Aegopodium podagraria has been a friend of man long before bishops were invented. We know this from the Danish bog burials of the Iron Age. Because of the acid content of peat, any animal or vegetable matter is liable to be preserved and cutters have always found the odd corpse in the peat which, as soon as it began to dry out, disintegrated to dust. Because of modern archaeological techniques, however, it is now possible to preserve these finds. So when in 1952, the corpse, which has since become famous

as the Tollund Man, popped out like a pickled onion, it was possible to subject him to proper scientific analysis.

He was found to be a man aged fifty or sixty, with a fine intellectual face, a bard or priest perhaps, not the sort of character you'd expect to be garotted and pushed into a bog and probably an instance of the religious customs of the German tribes recorded by Tacitus in the first century A.D. His teeth were worn but without any signs of decay and the contents of his stomach were found to include over a dozen sorts of common weed and seed including *Aegopodium podagraria*. The question no-one can answer is; had he just eaten a Danish prison's regulation-type breakfast of ordinary Iron Age porridge before execution or had he, as a fertility sacrifice, been given a ritual Last Supper of all the good things people wished to have in abundance? Either way it needn't affect our appreciation of Bishop's Weed.

The Latin name refers to the leaves fancifully cloven like a goat's hoof which have a deliciously nutty flavour when cooked as a vegetable. As Bishop's Weed spreads itself by a thick network of creeping roots, only thorough cleaning will eradicate it from the garden. As every little bit left entangled in the roots of perennial flowers, rock edging or paving stones, will grow and nullify your effort, it seems to me more sensible to learn to live with it. I have the plastic bucket for the kitchen alongside the barrow for the compost heap when I'm weeding so that I can throw in the more succulent shoots for supper as I work, doing two jobs in one.

I put down plenty of leaf-mould and manure in a thick top dressing every year so that there is enough nourishment for all, then any clump of perennials in the border which can't hold its own is too feeble for our garden and better lost. Later on in the summer any shoots of Bishop's Weed we haven't eaten produce flowers. These are tiny, white and insignificant except that as their hollow stalks stand up well their flat umbels make a useful background for cut flowers.

Perhaps I should give a word of warning. It is better to harvest a known patch of Bishop's Weed in the garden because, if you trip through the woods in spring searching out tender shoots, you may pick Dog's Mercury *Mercurialis perennis* L., by mistake. This poisonous plant carpets the

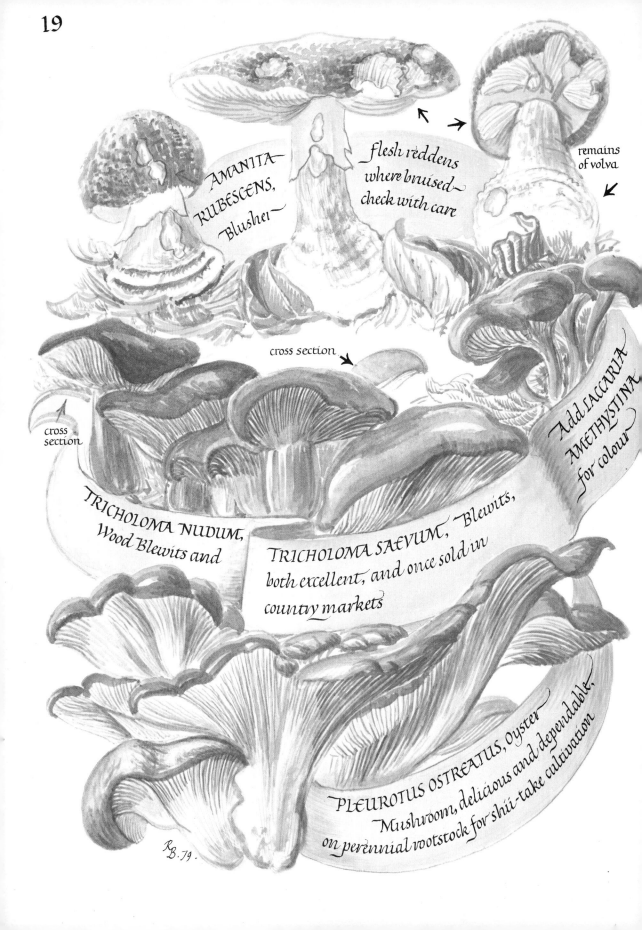

AMANITA RUBESCENS, Blusher

flesh reddens where bruised — check with care

remains of volva

cross section

cross section

Add LACCARIA AMETHYSTINA for colour

TRICHOLOMA NUDUM, Wood Blewits and

TRICHOLOMA SAEVUM, Blewits, both excellent, and once sold in country markets

PLEUROTUS OSTREATUS, Oyster Mushroom, delicious and dependable. on perennial rootstock for shii-take cultivation

R.B.79.

ground in similar fashion and painting has taught me how alike are the unfolding shoots. Though, later on, its leaves may be seen to be entire, mint-like, rather than cloven-hoofed, such differentiation may by then be too late.

Some species we found, some we brought in to Dalgairn. Good King Henry, *Chenopodium bonus-henricus*, is typical of the old-fashioned vegetable that I have only found growing in ancient gardens. This European precursor of our modern South American varieties of spinach and its relation, *Chenopodium album* L., Fat Hen, have been enjoyed since the days of the Stone Age, but whereas Fat Hen is an annual still to be found in every odd corner of waste ground, the perennial form, Good King Henry, has a scattered distribution mainly in eastern England. I have only found it twice; in the garden at Megginch in Angus, where the old castle garden has taken tradition straight on from the older monks' garden, and probably an even more ancient garden on this favoured site in the Garse of Gowrie, and at Carsaig in Mull, a true oasis, a garden hemmed in to its coastal shelf by high moorland and basalt cliffs, the pentagonal 'organ pipes' of nearby Fingal's Cave and the Giant's Causeway. As it is perennial but dies down in winter it is no good putting it with the other beets where people dig. In order not to lose it, I think it needs a little cottage garden patch to itself.

You can eat most of the goosefoots, which is all *Chenopodium* means, deriving from the shape of the three-lobed leaves, the snag being that the leaves are very variable in shape and the different species hard to identify. Most commonly met with are the Oraches, Common, Frosted and Hastate: *Atriplex patula* L., *A. laciniata* L. and *A. hastata* L. If truth be told, I still can't really tell them apart but the Frosted is the one with the whitest, mealiest flowers you find in late summer on the seashore or by roadsides so dusty that even the most dedicated Friend of the Earth would hesitate to cook it for dinner. Never mind, if you are a bread-baker, take some of the husky flowers or seeds (you can't even tell the difference between them without a good look through a lens) to put on top of the bread, as they are passably like American buckwheat.

Lamb's Lettuce or Wall Lettuce, *Mycelis muralis* (L.) Reichenbach, I found growing in the station yard where, by the wall, it must have just

enough lime to make it feel at home in Scotland as I have usually seen it in Dolomite woodlands. It is most elegant, often more than a yard high with arching purplish serrated leaves under a shower of tiny starry flowers, so many and so branched that, when you come to paint them, you find them growing all over in opposite directions.

You can eat it cooked as a vegetable like its cousin the Sow-thistles, *Sonchus* species. Trim the bristly edges of spring leaves. Personally, I prefer to see Sow-thistles flowering when they are that big and put only little green plants into the kitchen basket when I find them growing where they shouldn't in tidy rows of seedlings.

Although the *Petasites*, Butterburs, don't taste as good as their name and salad-like appearance might suggest, I include them because they are commoner in the north where, by wayside and in woodland, they are persecuted as dirty weeds. It seems to me ungrateful, because a plant has rank foliage later on, to forget that it flowered in early spring when there was hardly anything but snowdrops to cheer us through the driving sleet showers.

Petasites hybridus (L.) Gaertner, Mey & Scherb., is the biggest but very variable, as its nomenclature shows, and grows in damp places while *P. fragans*, (Vill.) C.Presl., Winter Heliotrope, colonises open woodland. Often, even in January, I have been able to pick my wife a little bunch of its scented mauve flowers so I thought it odd to find a friend poisoning it so that he could grow more fashionable alpines.

Horsetail, *Equisetum arvense* L., that strange primitive fern-like shoot related to the great prehistoric forests which have come down to us as coal is also to be listed among the worst of weeds because it rises from a sort of mattress of tough black roots next to impossible to get out with a spade. Luckily it is one we aren't bothered with here but, like all real baddies, it is to be overcome by kindness. Feed it generously with rich mulches and hoe the shoots as they appear because it is an indicator plant of dry, poor land to be vanquished by a rich tilth. Yes, now I remember, there is a patch of it adjacent to the lower corner of a vegetable plot, but in ten years it has never tried to invade the dug ground so I shall cite it as proof of pudding: thick mulches, big barrowloads of dung, leaf-mould and compost *do* work.

Bracken is another prehistoric species, a fern rising similarly from a tough spreading mesh of roots. Not being a hill farmer with pastures to keep clear, I confess that I rather like a little of it, associating its delicately unfolding fronds with bluebells, and the dry acid heathland of countless rambles in spring, when the first Fritillary butterflies flit among violets. It was definitely eaten in the war but I have never found it particularly good and, as recently it has been found to contain a carcinogen, or cancer-producing substance, if is off the culinary list. Just go on cutting the fronds as they appear and enrich the ground till it goes away or, at any rate, retreats to poor heathy woodland where it belongs.

Horsetail

In the lower part of the garden where, as cultivation had been gradually abandoned, Coltsfoot had colonised two quarter-acre patches, it proved better to use a scythe on the lighter land so that it reverted to rough grass. Indeed, provided you work backwards, kicking with your heels to discover such hazards as old bricks, rusting iron and barbed wire, you can drag the

rotary grass cutter after you, blazing a trail of rough grass paths through the jungle and getting even really strong patches of Coltsfoot under control. Coltsfoot, *Tussilago farfara* L., is another so-called 'baddie' with a heart of gold if handled right. Don't try to fight him with a spade: he'll win every time and loves nothing more than for some fool to blunder in with – 'What this place needs is a bit of a clear-up and then I'll give it a good dig over'. After a bonfire and some rough spadework, every three-inch bit of chopped-up root is ready to produce its own new plant in record time to tighten its grip on the newly dug plot. In Scotland it is called Dishy Laggie, a corruption, I suppose, of *Tussilago* but showing a real down-to-earth digger's respect for these roots coming up like dishes full of spaghetti. Because it is a plant indicative of poor soil conditions you can only kill it with kindness. Put on really thick mulches of compost, leaf-mould and manure and work them into your vegetable plot and any sprouting shoots of Coltsfoot may then be easily pulled out by hand. In poor grassland I find it better to let it be. The yellow dandelion flowers stud the turf for early bees and, if they get too uppish, are easily cut down with a scythe. On the other hand, if you have a dump, slag tip or railway embankment handy, then you'll probably be able to gather sufficient to make coltsfoot wine. The best recipe calls for a gallon of flowers and, though the wine is very good, I'd be more pleased to be able to pick that quantity outside the garden.

Chickweed, *Stellaria media* L., is a common weed of disturbed ground which means that, when you find some on a rubbish heap or in an abandoned hen run, you will probably find enough to make a good picking either for a salad or to cook as a vegetable. As it has such weak cress-like growth it is particularly suited for sandwiches in combination with such things as Marmite, tomato and sardines to stick it together.

As a painter in Fife, I find that I'm often about on the rubbish tips: if you want the most magnificent view of estuary, old kirk or castle across the bay in half a dozen instances follow the dustcarts. Here is your *point de vue* among the old beds and burning tyres with, as often as not, a nice picking of Chickweed at the edge as you scramble back up the cliff over a shute of rusty tins.

LEPIOTA RHACODES, Shaggy Parasol, ideal for woodland cultivation

cross section

BOLETUS EDULIS, Penny Bun, dried for winter flavouring

tubes

CANTHARELLUS CIBARIUS, Chanterelles, smell of apricot

HYGROPHOROPSIS AURANTIACA, good to eat

'bloody' juice

FISTULINA HEPATICA, Beefsteak Fungus, good with roasts

RB. 79

Living in a Wild Garden

Now that improved ferries and motorways have made the Dordogne as accessible as the Cotswolds, more people than ever before wish to relate delicious meals they eat abroad with what they can find growing at home. With fungi this is where trouble begins: *le menu gastronomique* in a good restaurant is one thing, a dank wood full of evil-smelling toadstools is quite another and no amount of *cordons bleus* can be plaited into a rope safe enough to bridge the chasm in between. Confused memories of Perigourdine fungi markets make it all worse: brown, yellow and orange pyramids of *ceps, bolées* and chanterelles, not to mention *trompettes des morts*, like dried purple-blotched toads' bellies turned inside out, are enough to send most Britons into a fearful last ditch stand, a no-nonsense laager of corned beef and baked bean tins, until such an assault on their insular culinary prejudices should be past.

Living in a Wild Garden

Trompettes des morts

Take courage, however, you cunning cooks on shrinking budgets, because the easiest and safest place to start is on the motorway. As we all increasingly traverse Europe at a steady 100 kms per hour no-one can fail to notice the elliptic white fungi springing up at the roadside. *Coprinus comatus* is immediately recognisable even to a careful driver by its English names, Shaggy Inkcap or Lawyer's Wig, and by its preference for growing on recently disturbed earth. That's why it always grows at motorway interchanges.

Yes, I know you're not allowed to stop but I'm used to driving in Italy where the largest juggernaut, coming to a sudden halt in a hiss of air-brakes, leads you to suppose a most dire emergency till you see the driver get out with a carefree smile to buy peaches from a roadside stall. Just fling up the bonnet on our own motorways, say you thought you smelt burning rubber or suspected overheating and even a Colditz-type autobahn pat-rolman will be mollified. Don't overdo it of course, to stroll coolly back from a country ramble laden with baskets of treasure to explain a car obviously parked on the M1 in the rush-hour is beyond even my powers of subterfuge.

So, gathered with circumspection, provided your Inkcaps are shaggy white and clean, there is no possible room for error. The only species that could possibly be mistaken for Inkcaps, *Coprinus atrimentarius*, is smaller, smooth-grooved and dirty grey. Though edible, it is a species causing

75

nausea if eaten in conjunction with alcohol and associated with the drug 'Antabuse' used in drink cures. A friend had it whilst staying with the Borgias with most awful withdrawal symptoms in the Sistine Chapel, all rather embarrassing and hard to explain, not to be recommended.

Don't leave your Shaggy Inkcaps hanging about till they deliquesce either. Auto-digestion begins in a few hours and quickly reduces your potential dinner to a black slimy mess in the boot of the car. Anyhow, to eat over-ripe fungi, even more than fruit, courts diarrhoea and disaster, so never gather more than you can cope with immediately. Cook them in a saucepan or covered casserole with just a knob of butter and seasoning as they will yield their own juice. They may be eaten as a vegetable, the juice being made into sauce or soup, any excess of which will deep-freeze.

Apart from roadside verges, old rubbish tips are the most likely places to find *Coprinus comatus*. Only once did I have a little colony at the back of the house following some drainage works but it soon died out as soil conditions returned to normal. There's no point in trying to grow it when roadworks are done on a scale which would have made the gardening ambitions of a Victorian Duke seem cheese-paring by comparison.

Each time I pass our local spaghetti junction I notice where the bulldozers are dumping soil as they grade embankments and cuttings. I note with glee as they replace topsoil and put down grass seed, spending millions of pounds reckless of expense, because I know they are but preparing the ground for a huge unbidden crop of Shaggy Inkcaps. The engine gauge stays normal but I feel the temperature rising. Perhaps even in Scotland the crop will be too liberal for such frequent overheating? I must spy out the less frequent sliproads where one could, with plausibility, imagine that one had lost a filler cap or a wheel-trim.

Next, who's for puffballs? The bigger, the better, provided that the flesh is still as tender and white inside as a fresh loaf, and has not begun to turn colour in its change towards becoming one of those husks full of powdery brown spoors (there may be up to seven billion of them) which boys love to kick. *Lycoperdon giganteum* is the biggest. It is recorded as having grown to a diameter of several feet, so large that people have even sent for the police. Fetch a bread knife instead. Saw it into slices for frying

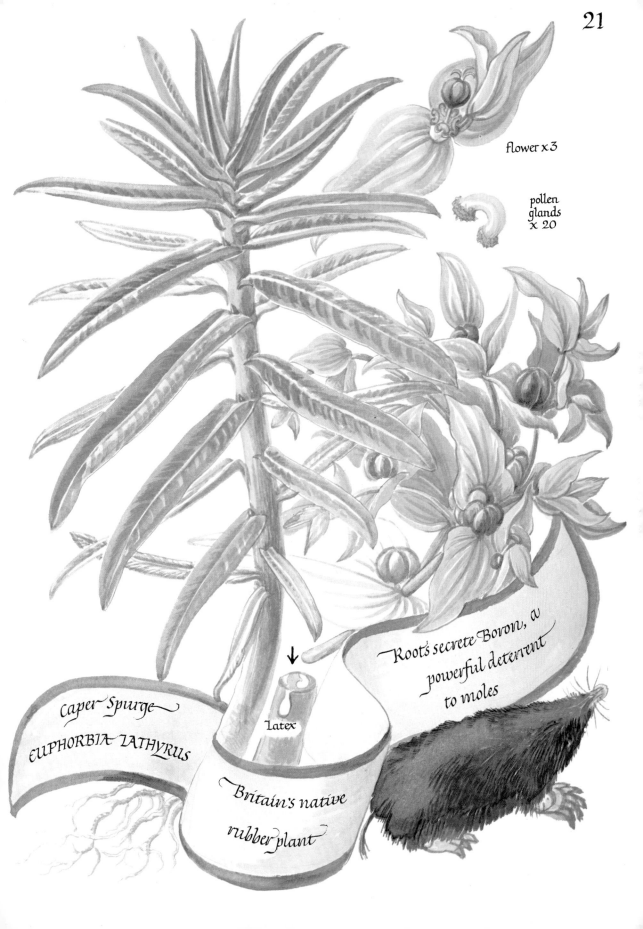

flower x 3

pollen
glands
x 20

Caper Spurge

EUPHORBIA LATHYRUS

Latex

Roots secrete Boron, a
powerful deterrent
to moles

Britain's native

rubber plant

Death Cap Fly Agaric

with plenty of pepper and salt on both sides or treat it like aubergines,
making a big moussaka, ratatouille or any of those happy peasant dishes
which are so cheap, given a big supply of Mediterranean vegetables, and so
prohibitively expensive unless adapted to what is readily available here.

Just don't leave *Lycoperdon* lying about. A most sober chum was never
quite the same after groping round our kitchen table in the dark. He let out
a yelp of terror as his fingertips told him he'd got hold of a skull: it's the
suède-like softness of the skin that gives people nerves. So, even more than
with most fungi, never let the unconverted see anything but the finished
dish.

Provided, as I say, that they are fresh and white inside, you can eat the
smaller puffballs too. *Lycoperdon caelatum* is about the size and shape of a
pear and identified by its warty cracked mosaic surface. *L. excipuliforme* is
the size of a golf ball and covered in granular spines. They may be
commonly gathered from sandy turf at the seaside, though at St Andrews
people shout 'Fore!' and leave golf balls about in the turf to confuse one.

Perhaps one should not mention any fungi small and white without a
warning about the Death Cap and the Destroying Angel: *Amanita phal-
loides* and *Amanita virosa* are both deadly because their toxins are tasteless,
unaffected by cooking or by human digestive juices and are thus absorbed
into the body before the victim has any warning, too late for vomiting and
the stomach pump to be of any use. For the first time recently there were
reports of a successful treatment in France but no-one wants to lay
themselves open to anything of that sort. In the thirty years or so that I
have been gathering, cooking and eating fungi, I have never given myself
even a moment's unease or indigestion because I have never taken a chance
and always erred on the side of caution, discarding countless potential
dinners because I could not be quite certain that I could trust my own
identification. That was before the excellent Collins' Field Guide was
published. Now it is all much easier but there is no substitute for, or short
cut to, a proper scientific approach; and old wives' tales about peeling and
silver spoons are worse than useless. When mushrooms alone have four-
teen or fifteen different species, all little white buttons when young, it is
safer to begin with Shaggy Inkcaps and big puffballs.

Fisherman's Fungus

The *Amanita* family are all distinguished by a universal veil, enclosing them when young like a soft-shelled egg. Later on, remains of this volva or rings can be seen plainly at the base of the stalk, which is why a picked white mushroom must always be suspect: one must have the whole stalk or stipe to be sure. A family party can gather baskets of beautiful mushrooms and, as they wander home through the fields, a child may pick and throw in one last little button. Familiarity has dulled the standard of exact and individual inspection needed at every stage on the way to the kitchen and a fatal condemned man's breakfast is the result. Most frequently encountered is the Fly Agaric, *Amanita muscaria*, bright red with white warts on the cap. It is poisonous but only fatal in large quantities. Indeed, the Vikings used to eat it in order to work themselves into a frenzy and go berserk.

I should be pleased to hear of a reliable quantitative recipe: it could have a future as a last resort savoury for an otherwise irredeemably dull party. Certainly rabbits and squirrels eat it and I have yet to see one running amok with a battle axe.

Yet even within the dreaded family of poisonous Amanitas, there is the Blusher, *Amanita rubescens*, edible and good. I have gathered it regularly in the pinewoods for over thirty years now without any worry over identification because although blushers have the basal volva and veil typical of their poisonous relations, they blush unmistakably, wherever the flesh is cut or bruised. Usually you can see a rosy hole where squirrel or slug has nibbled but, as you chop up perfect specimens, leave them for a few minutes to colour as a double check before adding them to the risotto.

To grow wild mushrooms and edible fungi in the garden is quite easy, provided you can match the right species to its suitable habitat. By simply collecting spoor or seed from the gills before cooking you can, as it were, eat your mushroom and still have it. I have never had any success with mushrooms bought from a shop but leave any species you have gathered fresh from the wild, gills down on damp paper for a few hours, and you'll be amazed at the resulting spoor print. Apart from being scientifically useful in identification, the paper may then be torn into shreds and slipped under damp leaf-mould, mossy grass, the bark of a wet log or wherever is

fruit
x 3

Couch Grass
AGROPYRON REPENS

Broad—leaved Dock
RUMEX OBTUSIFOLIUS

Lady's Bedstraw
GALIUM VERUM

Cottage Garden Marigolds
CALENDULA OFFICINALIS

x 3

Self-heal
PRUNELLA VULGARIS

Daisy (Day's eye)
BELLIS PERENNIS

RB

appropriate, and next year when you have forgotten all about it – Hey presto!'

Species responding well to this treatment and now producing several basketfuls a season are the Shaggy Parasol, *Lepiota rhacodes* and our local species of the brown-capped blood-red-bleeding Wood Mushroom *Agaricus langei*. They have settled down in the dry litter beneath the big Wellingtonia at the edge of the lawn and seem to be very hardy. They survive being picked and scratched up by the hens and they will even grow under the almost total shade of an old spruce plantation. Parasols are particularly suitable for drying for winter use. A few hours in the plate warmer safely dries off all the moisture so they may then be kept for months. Provided you remember to soak them well beforehand, they are ready for use in a big glass jar, their chocolate shingled caps an ornament to the mantelshelf, or hanging up among the onions and herbs threaded on strings with a big needle after the manner of old continental kitchens. In shops you now have to pay several pounds for a little packet of dried fungi and, to my mind, there is no better way of transforming an aged hen into a passable Coq au Vin than plenty of mushrooms.

People who ask about fungi usually lead me first to *Piptoporous betulinus*, the corky white bracket found on birch known as Fisherman's Fungus because it's useful to hook flies on. The Romans used it as a razor strop, so if anyone feels like making it tender in the first place, whether it is good or bad to eat could be a secondary consideration.

The second well-known fungus and one which haunts the imagination of any house owner is *Merulius lacrymans*, Dry Rot. There are in Fife, darkly whispered stories of this fungus, too, having been planted; an implacable dowager paying off old scores with an infected log in an unfrequented wing of a rival's castle; an heir popping toadstools down the cellar in the hope that he'll shortly be able to collect the insurance and settle for site value of his huge and hideous heritage. Regretfully there's no real basis for truth in such tales, because the air is so full of spoors all you have to do is provide damp airless conditions for them to take root and flourish; trees too near the house and blocked gutters, a damp wall and unaired rooms are all that is needed to invite it into your house. The recess

behind a shutter is a favourite place for it to start even in a room in daily use. Curiously enough Victorian houses are more prone to attack than Georgian or older because, when timber was rough cut with an adze, builders left a two-inch gap between wall and lath and plaster so that air could circulate. With the advent of the machine-cut timber they were able to economise and save an inch of space, with the fatal result that, when the stonework dried and powdered with the new-fangled central heating, the wall cavities could block more easily and the vital air circulation be prevented. That inch saved spells doom for many a pile of Victorian splendour.

You can't even eat it: if only *M. lacrymans* were delicious you could set up Scottish baronial fungus farms in the danker glens as the Chinese grow shii-take and recoup some part of your losses from the sort of people who buy chocolate-covered ants in Fortnum's. I'm quite serious, several of the wood-rooting fungi are more highly esteemed and easier to grow than our own single commercially known mushroom, *Agaricus bisporus*.

At Dalgairn we had another member of the dry rot family which you can eat, outside the house on the west lawn. Honey Fungus, *Armillaria mellea*, spreads by a similar rooting system of black rhizomorphs saprophytic on the roots of dead timber. Ours ran about the grass for ten years pushing up fruiting tufts of amber clustered toadstools in all sorts of corners wherever the dead roots of a former large beech tree have reached. Though *Armillaria* has been the ingredient of many a rich saucy dish in our kitchen there was something sinister about the way those rhizomorphs wriggled like little black snakes between the bark and the wood of the old stump. Now it has died out and I don't think I'd introduce it if it weren't there of its own accord, unless I had a beech stump well away from the house in rough grass.

You may be lucky enough to have oak stumps in your garden. If so, keep a look-out for something like a big squashy toad crouching in the grass by a corner of the bark. If roughly handled, it will bleed red drops like juicy meat for this is *Fistulina hepatica*, the Beefsteak Fungus. This has been a favourite of mine since I once taught in a fashionable prep school where the boys were allowed to make fires and cook on Sunday afternoons. Their

Leopard's Bane, healing Arnica, DORONICUM PARDALIANCHES

Meadow Clary (Clear Eye), SALVIA PRATENSIS, use for bathing tired eyes and soothing hay fever

Eau de Cologne Mint, a variety of MENTHA CITRATA

Eyebright, EUPHRASIA OFFICINALIS, clears bloodshot eyes

Yarrow, ACHILLEA MILLEFOLIUM, makes a cooling compress to staunch bleeding

x 3

flowers x 3

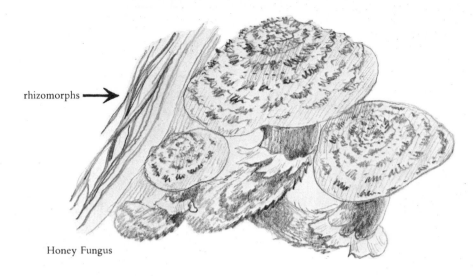

rhizomorphs →

Honey Fungus

usual fare was charred toast and sausages, but one weekend when I was master on duty we found a great fruiting of *Fistulinas*.

'Oh, sir! Can we really eat it?'

In a twinkling their frying-pans were full of marvellously convincing 'beef steaks', enough for the whole school to taste. Though of course all slept peacefully that night, letters home in the vein of 'We have a new master who gives us toadstools to eat in the woods' meant that the Headmaster's and Matron's telephones never stopped ringing for days afterwards. No-one could ever say that school was dull.

My favourite wood-rotting fungus is *Pleurotus ostreatus*. Its English name, Oyster Mushroom, gives some idea of its superb texture, colour and taste. For culinary purposes it rates as high as blewits, and in the garden, though it has a perennial rootstock like *Armillaria*, it will not erupt unwanted in the middle of the lawn, being a less vigorous colonist of the log pile. It will even be content with a small shaded stump or even a single wet log, sending up its delicate brackets reminiscent of Ackermann prints of fan vaulting in King's College Chapel.

Jew's Ears, *Auricularia auricula*, also grow in the same way on the bark of elder trees. Cusped more like a little brown monkey's ear these swell up in wet weather and are much esteemed in the Far East. We eat them when I find them, throwing them in with whatever else comes to hand in general fungus cooking, so perhaps that is why we have never got on with them. I see that Jane Grigson in The *Mushroom Feast*, that encyclopaedic celebration of all edible fungi, mentions them with pig's liver, braised satin chicken and Yan Mei's *bèche-de-mer* gourmet, which sounds encouraging enough to make one want to try again. Obviously, if one had an old chalkpit or somewhere infested with elder, Jew's Ears would become one's speciality, but I find a Shii-take wood gives better results.

'The sheltered edge of a wood . . . the right amount of wind . . . above the valley fogs . . . moist but well drained' says the oracle but, as I have found Oyster Mushrooms growing on holly, horse-chestnut and elm lying about all over the place here it can't be too fussy.

All my wood-rotting fungi seem to have had a setback from two very dry summers but now when it is so wet I can think of several potentially good

Jew's Ears

sites. The difficulty will lie in *NOT* being helped: having complained for years about people not bringing in wood for the fire when they see it lying about, I shall have to do a U-turn. To label the more sequestered parts of the wood 'Shii-take site' invites ribald comment but as I see Shii-take logs advertised for sale '£7.99 – Special Offer' in my latest issue of the most exclusive gardening catalogue when I have been trying to give them away free for years, I have a sharp answer ready.

A happy species good to eat and easy to identify are Blewits. There can be no mistaking something large and definitely purple growing in a ring of thirty feet diameter so that, if you stumble upon one, you can follow the circle round and you'll find a score. The only other bright purple toad-stools are *Laccaria amethystina*, wholly deep violet in colour when moist and possibly *Mycena pura*, smelling strongly of radishes. But they are both small, don't grow in a big circle and, anyhow, they too are edible. The two common and closely-related species of Blewits are *Tricholoma nudum* and *T. saevum*, a softer rosy lilac on top but still with the same violet scaled stalk. Both are equally delicious, chumpy to the teeth if not over-cooked, and a most colourful adjunct to any meal. I remember serving them up with roast beef at one of the first dinner parties I ever gave, the sort of thing one can only do in the blissful ignorance of one's student days. Luckily one of my guests was an Army Colonel whose distinguished war service had taken him behind the lines in the Balkans into the mountain strongholds of fungus-eating Partisans, but it says a lot for his trust and sense of humour that he and his wife have been friends ever since.

Blewits used to be sold in the Midland markets until quite recently, till the uniform dullness of urban food distribution persuaded even country people that there was no demand for their individual appearance and flavour. My wife and I look for them with most frequent success in larchwoods where their mauve caps stand out on the flame coloured carpet of needles fallen at the first frosts of October. For the last few years I have managed to get them going at home, too, now that my little plantations are grown sufficiently to provide shelter and a fine needled bed underneath for them to grow in.

Two other families which I would bring to the notice of beginners are

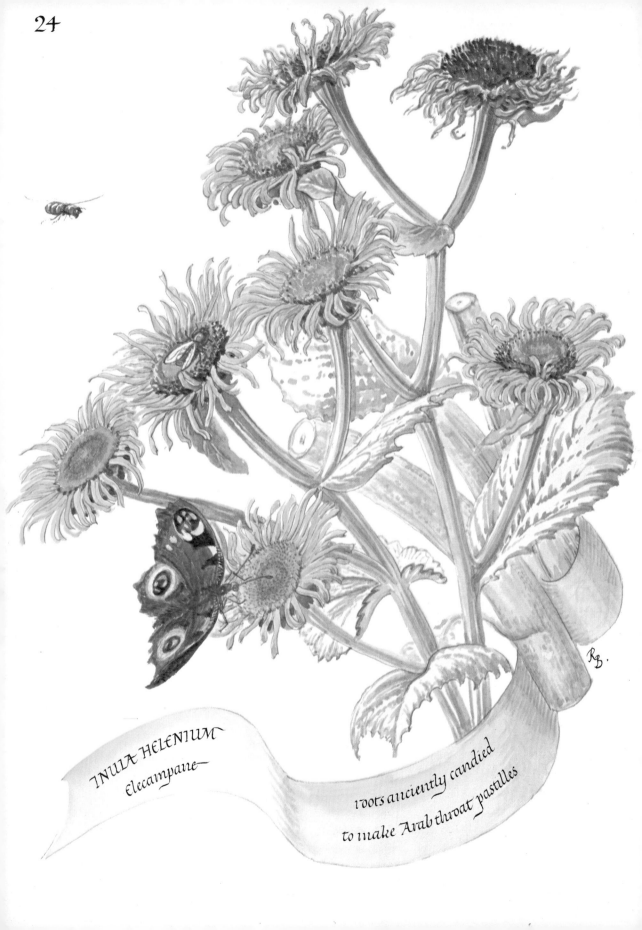

INULA HELENIUM
Elecampane

roots anciently candied
to make Arab throat pastilles

Chanterelles 'girolles', and Boletus, the *bolées* or *ceps* of France.

The former, *Cantharellus cibarius*, is funnel-shaped with gills rising imperceptibly from the stalk. It is both apricot in colour and smell and is to be found usually in beechwoods. It can easily be confused in appearance with little trumpets of *Hygrophoropsis aurantiaca*, usually more gingery in colour, or *Clitocybe flaccida*, a more leathery tan, neither of which have the distinctive apricot scent of Chanterelles, but are otherwise harmless and won't spoil the sauce. We first met this in Italy on a picnic in the Dolomites when my wife and I were sent into the forest to find fungi.

'What sorts?' I asked.

'*Tutti, tutti*,' the Contessina spread her arms to include the whole pine-scented prospect limited only by the skyline of sunlit peaks, so off we went, while our host coped with the fire. Uppercrust Italian families tend to bring up their children with good English governesses reading Kipling, healthy outdoor sports and Baden Powell, just as hopefully as their British equivalents put their puppy-fat daughters on to the ethereal spirituality of Giotto and Botticelli. Sometimes, something sticks. On our return there was a perfect fire with a witch's cauldron over it, suspended from a bough on tripods in the best boy scout manner, with the water just coming up to boil. In went the spaghetti, armfuls of it, really the easiest thing for feeding a large number when you think of it, much better than fiddling about with sandwiches.

Meanwhile we had felt rather put on our mettle and had arrived back with baskets of fungi, of all colours, known and unknown to me. I watched fascinated as our hostess, a septuagenarian whose fascinating past and war record had left her with many broken bones and only one eye, went through the baskets peering at the fungi like a hen picking grain.

'*Si, si, si, no, no, si, no, si, si.*' She went straight through boletus and morels, russulas, clavarias and ramarias, species notoriously difficult to identify, some good, some bad, some poisonous, with a deftness which would have left any mycologist gasping. I'd have still been at it, surrounded by books and microscopes, at tea-time.

The assorted fungi were all cooked in a saucepan and the sauce reheated at the edge of the fire. As soon as the pasta was cooked, the pot was

tipped and the water drained off. Then everything was stirred together with lots of butter, basil and seasoning in the cauldron. Easily served with a great wooden spoon and fork, a dollop in each bowl made a feast for twenty. There was even some left over for the dogs to lick out at the bottom. English gun dogs drooling spaghetti is a laughable sight, especially when, after a romp in the bilberries, they end up like purple-spotted Dalmatians.

Spaghetti and fungi picnics have been a favourite of ours ever since. You can vary it if you wish with mussels, fish, rabbit or even curried rice, nuts and windfall apples just according to whatever the season and setting might supply. In the kitchen Chanterelles go well with anything delicately flavoured. My wife puts them with dried apricots to accompany fish, trout in almonds and that sort of dish.

The last fungi I would wish to recommend on a beginner's list are Boletus, which have vertical tubes like a sponge under their caps instead of the usual radiating gills. As these provide shelter for a great variety of small acquaintances and turn slimy on cooking, they are to be scraped off previously with a knife or deft fingernail. Boletus are a large family of which I have eaten about eight or nine species, ranging from the best, *Boletus edulis*, like a firm brown bun with its underside a creamy yellow sponge, and *Boletus scaber*, distinguished by its dark-grooved stalk under the birchwoods, to *Boletus elegans*, slimy yellow in the pinewoods in spring, and *Boletus luridus*, one which bleeds blue when cut. *B. edulis* is the one you trust you get when you pay £6 a packet for them under the general name '*Porcini*' in an Italian supermarket but there has been such acrimonious correspondence on the matter in the press that it's far better to pick your own free.

On the other hand there are *B. piperatus* and *B. felleus*, both bitter to taste, if harmless, and *B. satanas*, the Devil's Boletus, very pretty with its red-meshed stalk and bleeding blue, which, though not deadly poisonous, is not good to eat. They seem to prefer sandy soil and pine plantations so I have never grown them in the garden, but then, when there are so many prettier species for garden cultivation, I'm content to leave the boletus woods as a goal for picnics.

Boletus scaber

Agropyron repens (L.) Beauv. Couch Grass, Twitch, Scutch or Witch has so far been one of my failures. Dogs and cats eat it with evident relish knowing intuitively that it will do their insides good. Culpeper holds it to be worth ten times its acreage in carrots but, though I know it's bungful of beneficial minerals, I have never managed to make it taste like anything other than a mouthful of sweet wet hay. As for the other authorities, Richard Mabey leaves it out and Audrey Wynne Hatfield talks darkly about 'infusions of whisker-freed roots for cystitis' an affliction which I have held in horror since the age of ten when my grown-up sister Vee was caught short on the busy Thames at Marlow Regatta. She told me to back the dinghy quickly into the rushes and not to look while she crouched over the stern. An embarrassed child, I rested on my oars and kept my eyes obediently shut, so I have always maintained that it was not my fault that, because rushes are resilient, the boat rebounded, as from a catapult, into the midstream throng.

In the cause of scientific inquiry, I have taken doses myself to see if it might, perhaps, have an opposite effect on an ordinary bladder and even tried it on Veuve Clicquot, the old black pug bitch, all to no avail: the only

crumb of medical opinion one of my researchers in Fife has been able to glean for me to pass on to those increasing numbers afflicted by this distressing complaint, is that doctors blame the wearing of tights as hot-beds of infection, and advocate a return to French knickers. Audrey Wynne Hatfield, whose gardening judgment I have learned to trust, says that Couch cannot stand tomatoes. By planting tomato plants for two or more years in patches badly infested with Couch, the latter will gradually die off and go away. I shall persevere in the most sheltered corners, although in Scotland we are hardly in the tomato belt.

I certainly never remember Couch being a problem in the South of France where one tripped out of one's mediaeval ruin (but madly chic) bearing the kitchen slop pail (not so chic).

'Où jeter, s'il vous plait, Madame?'

'Là-bas' a peasant thumb was jerked at the breath-taking view. When I looked over the ramparts after such simple garbage disposal by gravity, I saw that the peasant ordure of centuries had become a fine sun-baked silt, and that among the wild flowers the whole mountain chute was full of new potatoes and little tomatoes. Of course, down I went after them, cooking a resultant ratatouille-garbure that, notwithstanding some faint-hearts suddenly recollected they'd arranged to dine in Monte Carlo, was truly memorable. I forgot to look for any Couch.

As for ridding the garden of Couch or similar creeping perennials such as coltsfoot and bindweed, I am convinced that unless it can be done properly and continuously, the worst thing is to dig, because the real baddies spread by root propagation. Of course, if you can do double-trench digging, as in the book, or use a mechanical tiller, that's fine, but it means keeping at it like a real old-fashioned gardener, hoeing each shoot as it springs forth in joyful fecundity from Mother Earth, no nipping off to Spain for happy hols in the growing season, no time for friends or summer visitors who aren't prepared to join you on the treadmill every spare moment. I'd hate my garden to be like that, so I take comfort in knowing that as I can't begin to do the work which formerly needed four men, except in two small vegetable patches, I might as well accept the fact philosophically and sit in the sun to open another bottle.

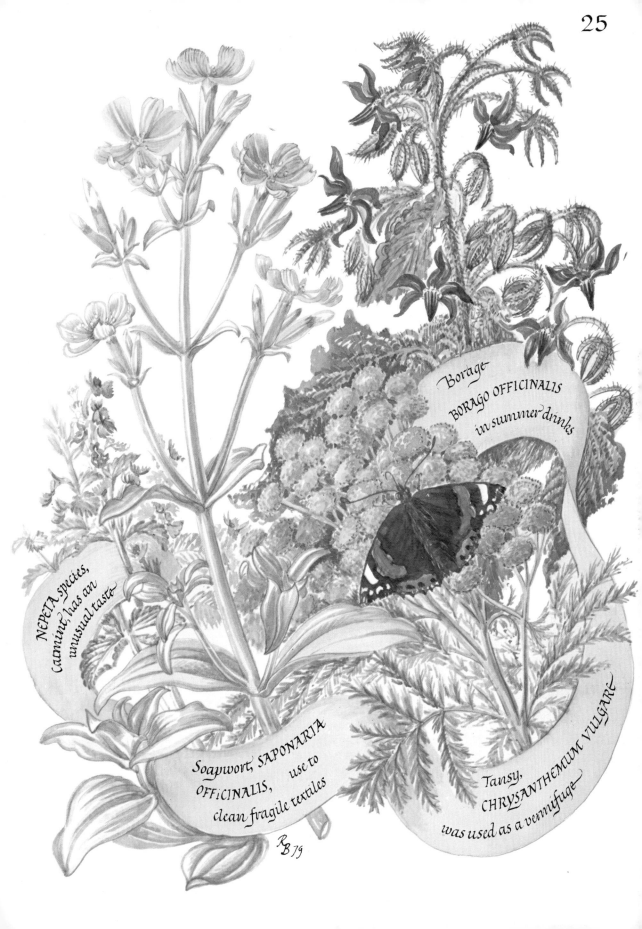

Borage,
BORAGO OFFICINALIS
in summer drinks

NEPETA species,
Catmint, has an
unusual taste

Soapwort, SAPONARIA
OFFICINALIS, use to
clean fragile textiles

Tansy,
CHRYSANTHEMUM VULGARE
was used as a vermifuge

RB 79

Living in a Wild Garden

Cottage garden Marigolds, *Calendula officinalis* L., the single ones with a button eye, should not be ousted by more showy innovations because, as well as being used for a soothing ointment, the flower heads and seeds may be dried for adding to winter soups.

Tagetes species, whether 'French' Marigolds or 'African', which came ultimately from Mexico via Australia as fodder for the mule trains used in the Boer War, are a 'must' for growing round vegetable plots in the old-fashioned way because their pungent foliage, like that of the onion tribe, gives off secretions beneficial to other plants. When nature will work for you in this way it seems ungrateful to throw out old lore in favour of unproven novelties.

One of my favourite plants for growing almost anywhere in my garden is Caper Spurge, *Euphorbia lathyrus* L., because from late summer onwards, you have the arresting growth of the seedlings when dark green 'ladders' of exactly opposite leaves rise in tiers from a stem as strangely bloomy as sloes or the lilac stalks of blewits. Next year this opens out into a sap green inflorescence in which, if you peer closely, you will see most curious tiny flowers, like fuses at the top of their time-bomb fruits. *Euphorbiaceae* are Britain's rubber plants. Break a little stalk, squeeze the milky juice on to your finger and you'll see for yourself – sticky Latex. Moreover, the roots give off powerful secretions of Boron, which is anathema to moles, forcing them to the surface so that the owls can catch them. Now, wherever I spot a line of heaps appearing in the grass, I transplant a few seedlings of Caper Spurge to adjacent beds and see no more of the little gentlemen in black velvet.

Eyebright, *Euphrasia officinalis* L., and Feverfew, *Chrysanthemum parthenium* (L) Bernh., come right up to date for the motorist's bathroom cupboard. If you have just driven several hundred miles and feel that your eyes are like gimlets boring into the back of your head, chamomile tea, as sold by Beatrix Potter's Mrs Rabbit under a sandy bank – remember? – will soothe a headache and ensure that you have a good night's sleep without the constipating effects of aspirin.

Formerly used for all inflammation of the eyes, Eyebright is marvellous at soothing that red-rimmed feeling. Many sufferers of hay fever and wearers of contact lenses find it worthwhile to have a decoction bottled and ready for use in the bathroom. Feverfew is even easier. Pick buds, flowers and even shoots, dry them on a tray in the sun and store like tea in instant readiness for a sleepless night. My wife and I find that about a dozen flowers in a little teapot of boiling water are just right for two small cups with a squeeze of lemon if we find ourselves wide awake worrying and making mountains out of molehills in the small hours.

Leopard's Bane or Arnica, *Doronicum pardalianches* L., has a dandelion-like flower in spring, common enough in the cottage-garden hedgerow. It is the basis of the old-fashioned general-purpose healing salve of that name bought in chemists'. Apart from its usefulness, *Doronicum* is a pretty flower which should be grown more widely.

I have suggested to several National Conservation bodies concerned with old buildings that they might care to accept a selection of suitable plants more in keeping with them than modern bedding plants but they obviously think I'm a nut-case. I don't mind because, although my easily grown old cottage flowers are rejected in favour of scarlet salvias, African marigolds, Superstar roses and other expensive twentieth century horrors as a setting for Tudor buildings, I suspect that, in the long run, I shan't be the one who looks the silliest.

One of my favourites is Cologne Mint for which I only lack the 'Eau' – alcohol. Once, when the Royal Research Ship needed repairs after an altercation with the ice, we put into the whalers' dry dock in South Georgia. The chief import to the otherwise officially 'dry' station of bearded whalers was aftershave lotion and Eau de Cologne. I often wonder

Meadowsweet, FILIPENDULA ULMARIA, with a scent of hay when dried

Woodruff, GALIUM ODORATUM, dried for linen closets

Great American Bindweed has the finest flower

CALYSTEGIA SYLVESTRIS

RB 79

what the shippers must have thought to find a few hundred hoary old toughs getting through more toiletries than all the inhabitants of Chelsea! Their drinks would, I suspect, have fuelled a Boeing. Lacking a still, put Eau de Cologne Mint in your hair rinse water.

Clary, literally Clear-eye, or Meadow Sage, both *Salvia pratensis* L., and the smaller *Salvia horminoides*, Pourr. are other obvious candidates for the 'Bathroom Cupboard' garden. In Britain, our Meadow Sage is becoming rare on its downland home and its chances of survival are not helped by its splendidly attractive purple flower but, in France, it is a common weed of Route Nationale lay-bys, so have no compunction about rescuing a few seedheads or seedlings from under the juggernauts.

Yarrow, *Achillea millefolium* L.; Self-heal, *Prunella vulgaris* L.; Lady's Bedstraw, *Galium verum* L. and Daisy – literally, Day's Eye – *Bellis perennis* L., were important healing herbs common everywhere.

Bellis perennis means 'throughout the year for the wars', an interesting sidelight on the facts of mediaeval life and though I don't suppose even the most rabid homeopath would forgo modern stitches and disinfectant for ancient flower power, one might try a cold compress tied on with a hanky to soothe a tired child's scratches on the way home from brambling. Every child knows the leaves of Dock, *Rumex* species, rubbed on quickly, neutralises the effect of a nettle sting and my wife's herbal, by Juliette de Bairacli Levy says that gypsies even use it internally in pile suppositories. I shall leave this particular subject to more experienced hands along with Nipplewort, *Lapsana communis* L., which doesn't get its name for nothing, and raspberry leaf tea, regular infusions of which are, I'm assured, extremely effective in assuaging painful periods for women.

Elecampane, *Inula helenium*, L., is a magnificent yellow daisy growing four or five feet high on a great clump of yellowish-green heart shaped leaves in late summer. It does well here in the semi-shade of woodland fringes, similar conditions to its home ground higher up in alpine woodland. It was reputedly candied as an Arab cough sweet but all I can say from experience that if you weren't wheezing before you began to dig up its mighty root, you will be afterwards. Better to grow it for the flower as it provides the perfect landing pad for late Vanessa butterflies.

Living in a Wild Garden

Two wild flowers of use in the linen cupboard rather than the kitchen are Woodruff, *Galium odoratum* (L.) Scop., and Meadowsweet, *Filipendula ulmaria* (L.) Maxim. The latter abounds in every ditch at midsummer while Woodruff raises its elegant leaf rosettes in the shade of old beech-woods. They are both to be harvested and dried as only then do they give up their characteristic scent. Packed loosely into muslin bags they lend your sheets the fragrance of new mown hay in place of the chemical bleaches used by the laundry.

Soapwort, *Saponaria officinalis* L., a recognisable larger-leaved cousin of our old-fashioned cottage-garden pinks, also comes in this grouping because, besides being a pretty wild flower of the meadow bank, a decoction of its scrubbed roots applied with a soft brush makes the gentlest cleanser for fragile lace and tapestries. It is still used by the British Museum restorers for this purpose and you can buy it in a good herbalist's but, when modern gardeners complain that the plant is invasive, why not grow it on the corner of a gravel path, somewhere you can easily keep it within bounds by pulling up the spreading runners for use in little household cleaning jobs?

Scrub a handful of roots, cover with water and boil for a few minutes, strain the liquid and apply with a soft brush to hangings too large or too frail to immerse in a bowl.

Catmint, *Nepeta* species, is to be used in the bathroom as a rinse, in the linen cupboard for fragrance and sparingly in the kitchen when one needs a touch of the unusual. For most recipes demanding cream, my wife uses home-grown yoghourt as being less rich for the digestion and the purse. By making addition of various mints to yoghourt, one has the basis of a sauce used from Istanbul, where it is stirred with oil into diced cucumber, to the Punjab, where it is served over little savoury dumplings.

Soapwort roots

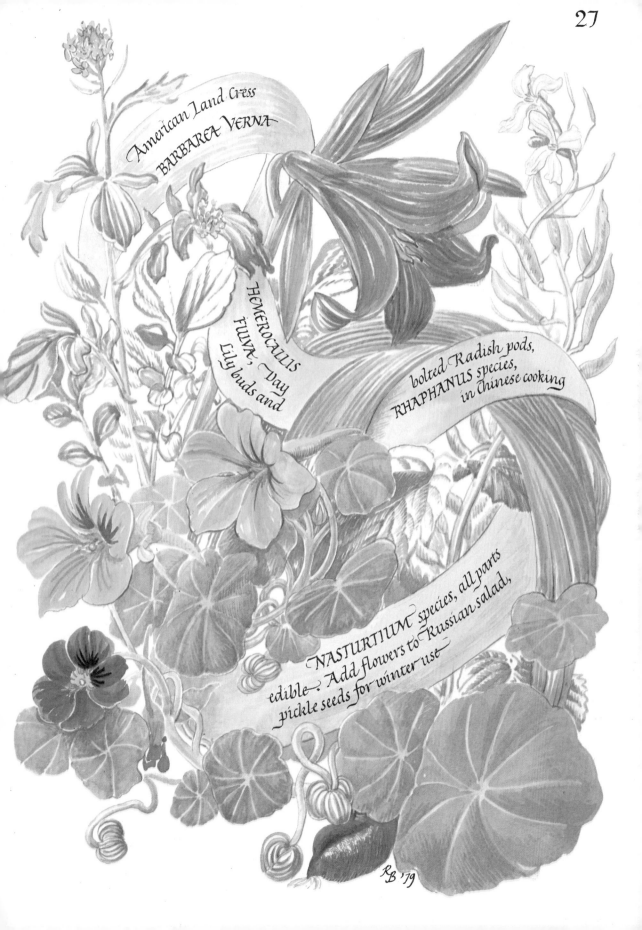

American Land Cress
BARBAREA VERNA

HEMEROCALLIS
FULVA, Day
Lily buds and

bolted Radish pods,
RHAPHANUS species,
in Chinese cooking

NASTURTIUM species, all parts
edible. Add flowers to Russian salad,
pickle seeds for winter use

RB '79

Living in a Wild Garden

Tansy, *Chrysanthemum vulgare*, a tough perennial, would pass unnoticed by many a wayside track, were its shaggy dull green foliage not to produce a mass of yellow button flowers above the dust of late summer. 'Tansy puddings' coo the whimsy-herby ladies, so I can do no better than quote Mabey in full:

> Tansy is an unusually off-putting plant. It smells like a strong chest-ointment and has a hot, bitter taste. Used in excess it is more than unpleasant, and can be a dangerous irritant to the stomach. Nevertheless, at Easter the young leaves were traditionally served with fried eggs and used to flavour puddings made from milk, flour and eggs. This may have been to symbolise the bitter herbs eaten by the Jews at Passover, though one sixteenth-century writer explained that it was to counteract the effects 'engendered of Fish in the Lent season'. He may have been on to something, as the quality of fish at that time no doubt gave much room for the development of worms, and Oil of Tansy is quite effective as a vermifuge.

More nice candidates for my nasty garden included Wolf's Bane, Fleabane and Bugbane – well, you never know what may be needed next. Wolf's Bane, *Aconitum vulparia*, a fine creamy yellow monkshood with a 'bee' in it, I discovered growing up the garden path leading to the local tax office, so it would perhaps be tactless to press any further enquiry into how it came by its name. Fleabane, *Pulicaria dysenterica*, is the common little orange button daisy of any English summer ditch, but rarely met with in Scotland, which is worth introducing to a damp habitat. Perhaps one should make good luck sachets to protect from flea-bites those given to rummaging in dirty second-hand markets?

Bugbane, *Cimicifuga racemosa*, sometimes called Snakeroot, is a perennial often found in old gardens, where it raises its graceful spires of little creamy bells in the August borders of lavender-scented ladies who, in referring to it daintily with Percy Thrower as 'Sim-iss-ee-fu-ga' have obviously never had trouble with infested mattresses, or had to deal with 'Chi-mee-chi' – bed bugs – in Latin lands of old. Now she knows, my wife doesn't think it quite so pretty in the house.

← tuber

Comfrey

On the way down to the garden was a drift of nondescript little plants with hairy green leaves and clusters of creamy-green bells – Comfrey, I realised in an absent-minded way and wondered why they didn't produce any pink and blue flowers like the Comfreys I was used to. Ah, well, light land, thought I, probably just a measly northern growth and suffering from drought or the shade of the trees, and gave the bit I didn't put the grass cutter over, a few shovelfuls of manure to see if I could encourage it to shoot stronger. All of which goes to show really how stupid I am. If I had bothered to look it up properly I would have seen that there are five sorts of Comfrey and that ours has a 'calyx with pointed teeth three times as long as the tube', and was in fact the Tuberous Comfrey, 'commoner in the north'. Since then, I have looked it up in the Botanical Atlas and find that it hardly ever occurs south of the border, so I am now proud of our little woodland weed, if not of my own casual unobservant approach. If one is a fool, it only compounds one's folly not to realise it and I was stung into reading more about the virtues of this admirable plant.

The Russian variety is so full of vitamins and grows at such a rate, like other plants which have adapted to the short summers of an extreme climate, that the British Ministry of Agriculture were encouraging its introduction as a fodder crop sometime ago. Our Tuberous Comfrey doesn't have this ten feet growth potential but then we have no damp ground suitable so we make the best of what leaves we have, using them as a general vegetable in early summer when the indigenous wild species can naturally be expected to produce growth before unacclimatised aliens. I see that, on one hand, Richard Mabey recommends sticking the glutinous leaves together in batter to make 'A Teutonic fritter called *Schwarzwurz*', while on the other, Culpeper uses the root for a variety of ills so unattractive that mention of them would put anyone off Comfrey for ever, so take your choice.

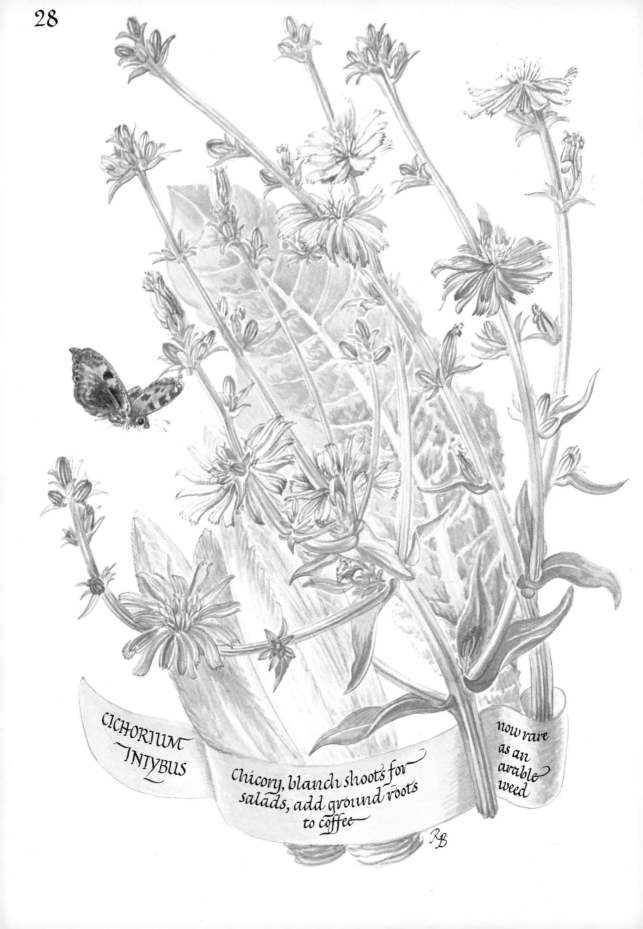

CICHORIUM
INTYBUS

Chicory, blanch shoots for
salads, add ground roots
to coffee

now rare
as an
arable
weed

RB

Hops Alehoof

Alehoof, *Glechoma hederacea* L., Ground Ivy, once called *Nepeta glechoma* because of its obvious kinship with catmint, is a woodland ground-cover plant. Formerly it was used to clarify beer and flavour it before the Tudor introduction of hops so it seems a pity not to grow them together as a reminder of times past. Even if you don't brew beer, you can still benefit from Alehoof's iron content by making a tea of this little plant which, according to Audrey Wynne Hatfield was once sufficiently important on the London streets to have its own 'cry'.

Alemaking like baking was a basically simple household task within the scope of any peasant. Saxon *Eale* or Celtic *Bere*, call it what you will, was made from wet barley beginning to sprout. Dried in a kiln, this becomes malt, which nowadays, people buy in a kit. Warm water and yeast begins the fermentation process. The sugar in the malt gives off carbonic acid gas, which is why, if you try to bottle it before fermentation is complete, a home-made brew blows up, and alcohol is left in the liquid. Of course, there is every refinement of flavour, hops, herbs, spices, dark or light ale and keeping qualities, but basic 'cakes and ale' are simple pleasures.

Hops, *Humulus lupulus* L., are a 'must' for any flower arranger's garden. The handsome vine will climb anything, even the wires of telegraph poles so is to be used as a general screening plant. The hops themselves, those curious pale green paper cones dangling from female plants in autumn come after the inconspicuous flowers and are most decorative rambling up any small tree or hedge.

Living in a Wild Garden

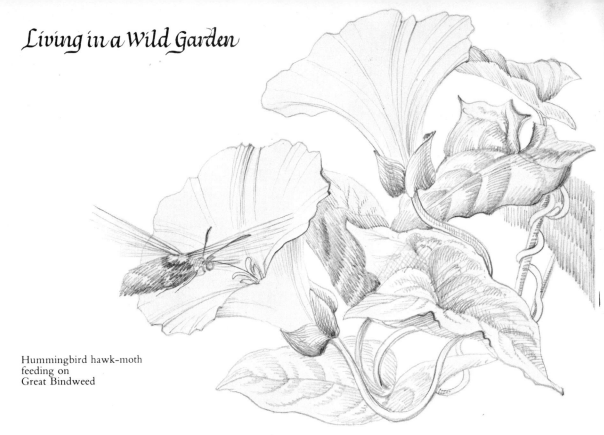

Hummingbird hawk-moth
feeding on
Great Bindweed

Bindweed comes in three sizes and I shan't bother to dwell on the smallest, Field Bindweed, *Convolvulus arvensis* L., which the Collins' Guide describes as 'a pernicious perennial, prostrate or twining anti-clockwise up to two feet long, a widespread common and tenacious weed of cultivated and waste places'. What is two feet of weed growth to me? – a mere tendril of flowers and arrow-shaped leaves to twine round the foreground stalks of some poppies and barley in a flower painting. We are on to the big stuff, the Great Bindweed, *Calystegia sepium* (L.) R. Br., grows eight feet long with white funnel-shaped flowers two inches across and the American Bindweed, *C. sylvestris* Willdenow Roemer & Schultes, 'is larger still with three-inch flowers and bracts very broad, much inflated at the base, often overlapping and completely enveloping the calyx'. Now there's a flower really worth growing, ten feet tall with pink and silver trumpets opening in daily succession as they turn towards the sun.

The poor plant's only fault is that it grows too well. Its tangled mass of roots like brittle spaghetti prove almost impossible to dig out and, in the past, I have tried taking rockeries to pieces, stone by stone, then excavating to the subsoil three feet below and sifting every bit of earth like a demented archaeologist, all to no permanent avail. Now I'm older, less energetic but more cunning, my answer is to scrap the rockery, because it's probably quite out of place anyway on the lowland depths of soil where bindweed flourishes. Why not use the stones to secure a framework strong enough for the bindweed to climb on and give it its head? Turn all that phenomenal growth to advantage. Feed your bindweeds well and get them up into the sun as soon as possible because once you have got the bindweed

overhead it will have exhausted its growth potential for the year and won't want to spread. Treat it like a hop vine, because when you can see where it is spiralling up in a thick hank, it is easier to keep control of the ground below, running the rotary cutter over any errant shoots at the base. The sheer weight of foliage can pull down any ordinary trellis, so unless I can plan a double arch or pergola, I use substantial tripods of holly logs lashed with fencing wire. When planning to call a truce with your old enemy in this fashion, you will find that the cool white bells of the Great Bindweed go particularly well with Dorothy Perkins roses, offsetting the cloying pink of these late summer showers of rosy posies which my wife finds so useful for the dressing-tables of visitors. Once they are established, common varieties of cupressus are also quite strong enough growers to carry a mantle of bindweed; I think their funereal green is improved by a wreath of white trumpets and long to introduce its cheerfulness to some city graveyards.

The American Bindweed has its pink trumpets delicately rayed with silver like Morning Glory, *Ipomeia*, so it is most effective to mix it with a dark red rose. With us it tangles harmlessly through old hedges of clipped beech, columnar Irish yews, into the glaucous blue of eucalyptus and over arches with roses such as *Rosa Henryi* and *R. macrantha* which flower before the bindweed gets going but whose big bristly hips and autumn foliage provide a happy foil for the Art Nouveau tangle of bindweed.

Another advantage of the deep rooting system of bindweed is that even in the record drought of 1976 it was scarcely affected. In fact, the luxuriant curtain of arrow-shaped leaves actually holds the dew or any moisture and makes cool shade for Day Lilies. Here again we grow the common old bronze *Hemerocallis fulva* and lots of it rather than any brighter cultivars, not only because its softness harmonises with the yellowing foliage of late summer but also because you can eat the buds as a vegetable. Because, in fact, I enjoy the sight of the bronze trumpet flowers more, we only eat lily buds to thin them or if we are going to be away. They are eaten in some Chinese dishes I'm told but, though unfamiliar to me, anyone who cares to snap off a little bud and eat it as she passes, can see for herself how good they could be in salads.

Living in a Wild Garden

Viper's Bugloss

Gardeners are always chucking out Day Lilies so if you poke round their old dumps you can easily find enough to make really thick clumps and hedges of it. When the clump has grown to be a good yard across, cut it up with a spade and a fork, cutting from the centre and lifting each slice from below, as you would a gooey gateau. Bury each spade-sized hunk in deep rich leaf-mould and next year it will be seen to refute its reputation for resenting disturbance.

Don't forget to eat ordinary garden Nasturtiums, too. I used to eat nasturtium leaf sandwiches as a child but now throw whole shoots, leaf, bud, flower and tendril into the salad, pickling the seedheads like capers for winter use. Nasturtiums have a piquant peppery taste besides their brilliant orange and red colouring which makes them ideal for adding zest to yesterday's cold potatoes which you had half-thought of pressing into service as today's Russian salad.

I don't see why food shouldn't be bright and cheerful so it's worth knowing half a dozen flowers to throw in for colour. Every magazine article pays lip-service to the idea of a sprig of Borage in the Pimms but I wonder how often people do it. I find Borage is seldom grown nor, for that matter, is Pimms often offered. But why not put it into the more homely cider or fruit-cups that all of us concoct with fizzy lemonade to spin the drink out on a summer evening? Why not pop them into fruit salad, too, or use Anchusa, that bluest of blue flowers in the herbaceous border, or Viper's Bugloss from the wild, as alternatives. They are all from the same family, *Boraginacceae*.

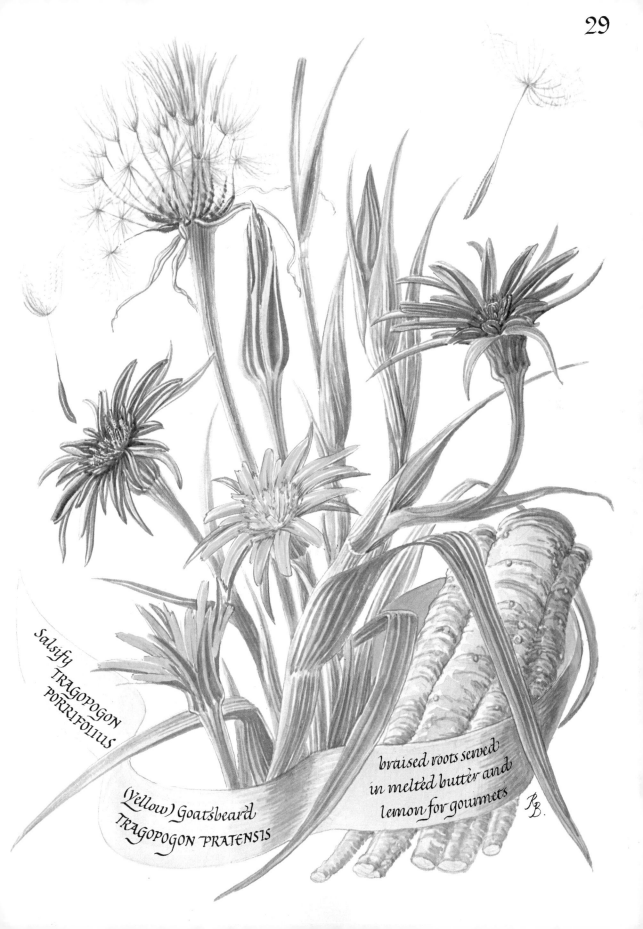

Salsify
TRAGOPOGON
PORRIFOLIUS

(Yellow) Goatsbeard
TRAGOPOGON PRATENSIS

braised roots served
in melted butter and
lemon for gourmets

R.B.

Living in a Wild Garden

Blue Curaçao varies a champagne cocktail and you can even get blue edible colourant for party food. 'Contains Brilliant Blue FCF Acetic Acid E123 Amaranth in Aqueous Solution'. I don't know what it means but with cochineal and marzipan, it will achieve black food, as I discovered when once asked to make a favourite black Persian cat on my daughter's birthday cake; after which the red flowers of Bergamot, *Monarda didyma*, and even the purple flowers of Meadow Clary, *Salvia pratensis*, seem more ordinary. Cowslips used to be used in cooking for making fritters but I rule them out as a sadly decreasing species; roses, too, in which the taste never comes up to the idea. Candied violets and rose petals? Well, yes, if you like fiddling about but they don't appeal to me, merely reminding me of those sweet-scented chocolates I most dislike.

Broom flowers are better; common and easily come by, they don't taste of much but cheer the appearance of camping or barbequed food and were much used for decoration in Tudor and Stuart times.

Aubrey Wynne Hatfield writes in what must surely be one of the first and most readable books on the subject, *How to Enjoy your Weeds*:

The worst villains in any garden are the buttercup tribe, the Ranunculaceae, which give nothing and take all the good things available, and seriously deplete the ground of potassium and other elements. The secretions from their roots poison the precious nitrogen bacteria in the soil so that other plants suffer from their deficiency. When the weed varieties, the bulbous or creeping buttercups, or crowsfoot as they are often called, get into a strawberry, pea or bean bed, they will dwarf these plants and cause them to panic into producing premature, small flowers. This greedy selfish family is a large one and its various members such as delphinium, paeony, anemone, clematis and many other desirable garden subjects, share the same incompatibility with other plants, so that their beds and their neighbours require constant feeding and replenishing. Another garden favourite of dubious character and breath is the gladiolus. It has been noticed that a bed containing a collection of these showy plants inhibited peas and beans as far away as 50 ft!

I always disliked those big fan-shaped bowls of gladiolus stuck on a piano or in the empty hearth of a hotel foyer but that hint of bad breath puts the lid on it. To be fair, there is a little wild one, *Gladiolus illyricus*, very rare, still to be seen wild in the New Forest, which I have also found in Portugal, so small and elegant that I should take its breath on trust.

To go back to the buttercups, all those aborting peas and beans is a dreadful thought to counter the golden prospect of delight in old summer pastures: I wonder how cows are immune? It would seem that they are all right in the hedge-bottom or water meadows where there must be sufficient annual renewal of potassium to provide enough for all, unless anyone has noticed some subtle deficiency about a June ditch which escapes me: on the other hand, one can't have noxious buttercup breath on the beans so the answer must just be to keep them well apart.

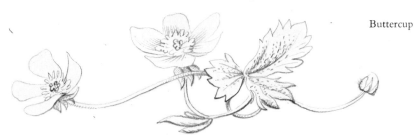

Buttercup

It struck me as sad to wait in the greengrocer's queue behind a lot of local ladies, who all looked as though they would be pleased to save 10p here and there on the housekeeping, and to watch them buying turnips or even bits of turnip, in and out of the scales, not too much, now it's too little. At last, I could stand it no longer.

'Why are you all buying turnips?'

The greengrocer is a friend of mine because I buy sub-standard goods in bulk on a Saturday, clearing the box of rotten tomatoes to make soup and that sort of thing. 'Why don't you pick them up free on every corner where they have fallen off the tractors at this time of year?'

They all giggled at such an eccentric notion. 'Ooh, Mr Banks,' one pretty young wife exclaimed, 'they're sheep's turnips.' It was my turn to be

107

shocked at such ignorance in a country town: a turnip is a turnip, regardless of whether used for sheep fodder, and if it's sitting there in the bend of the road, call it a swede or a rutabaga if you like but, for heaven's sake, pick it up, take it home and eat it. Peeled, cubed, cooked in a little water, then mashed with butter, salt and pepper, turnips are the perfect accompaniment for game or roast meat, any flavour you don't want swamped, a dish fit for a king. In fact, it is only a couple of centuries since George III kept a bowl of them on the sideboard so that he could extol the virtues of this recently introduced crop to his farmer friends and now when as a nation, we are all supposed to be so hard up, people spurn such homely food.

You can eat turnip tops, too, as a green vegetable and the little white Globe Turnip, if grown in the garden and picked young, needs no cooking at all. A recipe which I have known all my life, associating it with an octagonal breakfast set of the early thirties, chosen by my sister Vee, complained of by my father, bust even more quickly than usual in the kitchen and which I now recognise to have been Art Deco, is as follows:

Shred an inch-high pile of juicy turnip on to a plate. Grate an inch thickness of raw carrot on top of the turnip and cheese on top of that. Garnish the resulting striped pyramid with rings of tomato and squeeze plenty of lemon overall. Juicy, slimming and cheap, it was probably also introduced by my sister Vee in the Swedish health and beauty vogue of the period and I can vouchsafe its excellence for summer breakfast or slimmer's lunch.

Parsnips are another borderline species of vegetable in which the cultivated varieties are very little removed from the wild: indeed experiments have shown that wild stock will produce garden-quality roots within a decade. Both the commonness of the wild plant and a decline in popularity of parsnips as a garden crop or as a fashionable vegetable at the table lead me to include it here. I think it is probably due to the sweetness of parsnips which made them so popular until the import of cheap West Indian sugar, that they are in disfavour now. However, for excellence combined with both cheapness and easiness, this last a vital consideration with anyone who leads a busy working life, I know few supper dishes to equal one my wife and I have often eaten at Kellie Castle. Before a busy day doing two

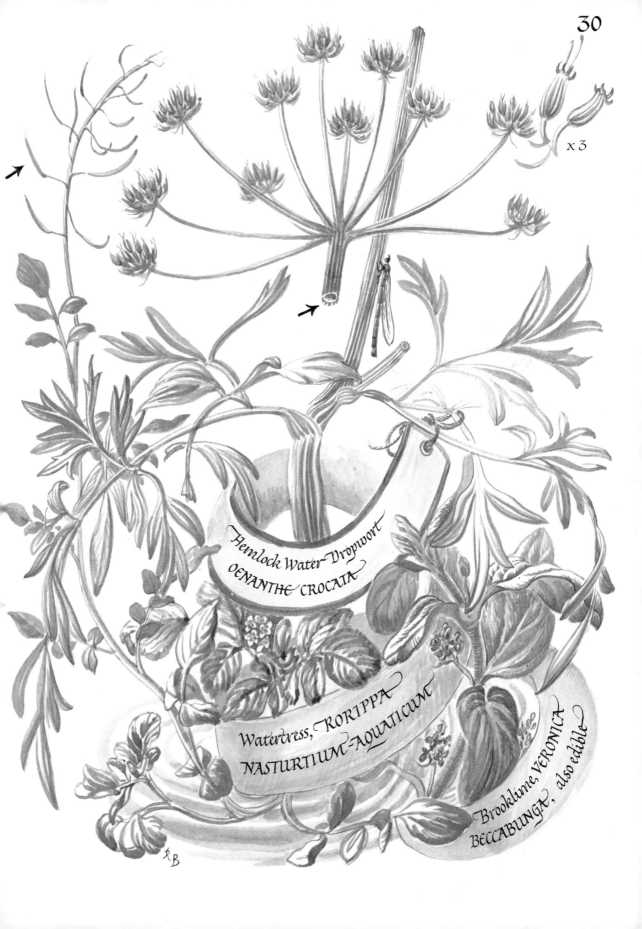

x 3

Hemlock Water Dropwort
OENANTHE CROCATA

Watercress, RORIPPA
NASTURTIUM-AQUATICUM

Brooklime, VERONICA
BECCABUNGA, also edible

R.B

jobs at once as sculptor and as Area Representative of the National Trust for Scotland, Hew Lorimer packs into a deep casserole with a close-fitting lid, layers of parsnips and leeks with a little butter and just enough stock to cover them. After an elastic amount of time in a low oven and half an hour before dinner, smokies are popped in on top. The mildly oniony leeks and the salty tang of the smokies, delicious little wood-smoked haddock that are the speciality of Arbroath in Angus, combine perfectly with the bland sweetness of parsnips to produce a dish suited to uncertain hours and minimal time to be spent on preparation and clearing up after cooking.

In the wild, parsnip is easily recognised along the downland track in the south of England as being the only umbellifer with yellow flowers apart from the feathery fennel. Both there and in the garden, its hardiness renders it impervious to frost, so it can be left in the ground as a winter stand-by, to be dug up for use whenever a mild spell makes it possible. In addition, its rank foliage is perfectly edible in its own right cooked as a green vegetable. As children we always had a picking or two during the spring when greenstuffs were in short supply.

Parsnip shoots

Chicory, *Cichorium intybus* L., once known as Succory, used to be a common enough wild flower at the edge of any Constable cornfield: it has bigger Cambridge Blue star flowers than the smaller Oxford Blue cornflower and both are now equally rare.

Cornflower seems accepted as a respectable garden annual but chicory

is out on the dump, which is a pity, when its shoots are so good to eat. Yes, along with inferior coffee, it is all the same plant, the thing which if you ask for it in the greengrocer's as 'chicory', a pert Miss will toss her head and reply 'D'you mean endive?' and if, as she's so superior and frenchified, you ask for 'endive frisee', the answer is 'Oh . . . chicory?' It is all the same plant, some varieties are grown like shredded lettuce and some forced in a hot-bed to make the tall pale, more tender chicons. In the East, I'm told the roots, as well, are cooked and eaten as a vegetable so it seems a shame to let chicory die out. Incidentally I found my original parent plant in an autobahn lay-by, the source of so many weeds common enough on the chalk and limestone across the Channel but here rare now and not to be disturbed. Poking round the fringes of a continental rubbish dump is likely to come up with a far more recherché candidate for your garden than the most expensive garden centre.

It is, I find, a characteristic of the Radish, *Raphanus sativus*, always to have been at its best when you have been away. Dreaming of French breakfasts as depicted on the packet, you return to a bitter woolly root like an old lobster claw under a straggly mass of little white flowers. Don't give up. Instead of pulling up your bolted radishes in a fury and consigning them to the compost heap, harvest the seedpods instead. Pick them young and green, before the seeds have formed, for salads or pickling and, human nature being what it is, people will be far more interested than by a bunch of perfect radishes that anyone can grow.

As a general vinegar for pickling things in, we buy the cheapest white malt vinegar by the crate in the supermarket. Pour out an inch or two from every bottle which, incidentally, will give you enough to fill two extras, then go through them all putting a teaspoonful of crushed peppercorns in each, a teaspoon of brown sugar and garlic to taste. Your cheap malt vinegar will now look and taste like the most expensive French wine vinegar. Place two or three sprigs of tarragon in each and it will be acceptable to the most discerning palate at quadruple the price on a 'bring and buy' stall.

In his excellent *Concise Encyclopaedia of Gastronomy*, André Simon writes:

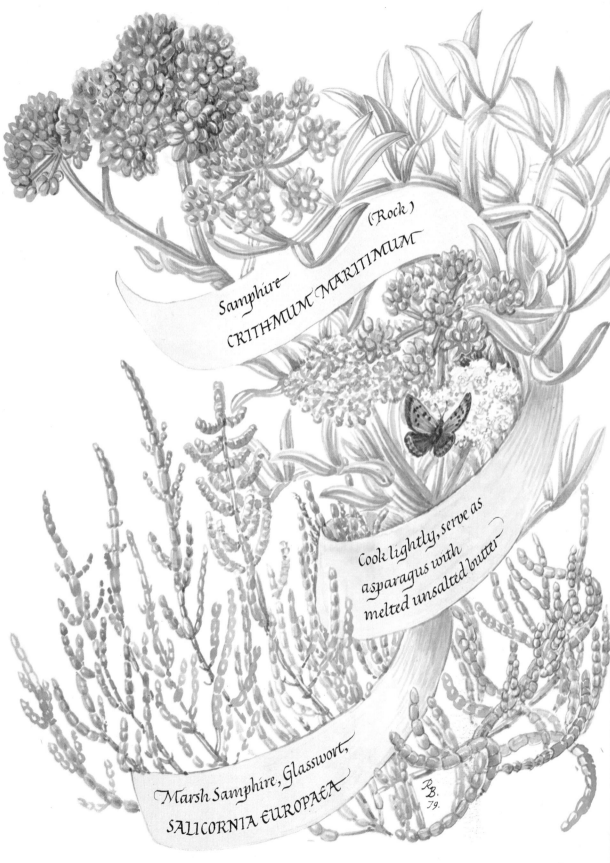

Samphire (Rock)
CRITHMUM MARITIMUM

Cook lightly, serve as
asparagus with
melted unsalted butter

Marsh Samphire, Glasswort,
SALICORNIA EUROPAEA

R.B.
79.

The average English middle-class household salad is an abomination, consisting of wet lettuce cut up small with a steel knife, uncored halves of tomatoes, stalky watercress and hard-boiled eggs, with a covering of linseed oil salad 'cream' from a grocer's bottle.

The same goes for Scotland without the watercress. I should like to think that in the quarter century since that was written things have improved a little here and there. More people are prepared to consider winter salads if only because of the difficulty of combining any sort of entertaining with dishing up hot vegetables; better to have shredded cabbage, carrot and beetroot cold and ready on the sideboard beforehand, than to get hot and bothered in your best dress over sprouts burned at the last minute.

There are, however, so many other things one can put in that people have written whole cook books on the preparation of salads. For our purposes it will suffice to say that the addition of chopped onion and garlic will improve the flavour and raise resistance to winter germs, and an orange or two cut up with a squeeze of lemon, will add still more Vitamin C and sharpen the salad to counteract the greasiness of so much of our winter food.

A classic French dressing, 3 parts olive oil to 1 part vinegar, pepper and salt, may be varied with more lemon, bits of wine left over, all sorts of mustard and even a dust of curry powder if a salad looks a little too coarse.

'Your salads always seem to be different' is so often the cry that it is as well to consider honestly what one does on a frozen-foggy Sunday morning faced with the prospect of so many extra to dinner. One stands over the vegetable rack and, with luck, the wreckage at the bottom sorts itself into two categories; roots which can be cleaned, cut up and either cooked to be eaten hot as ratatouille, or allowed to cool as the basis of salad and green vegetables whose tiredness won't be apparent under French dressing. The first category is likely to include beans, beetroot, cabbage and cauliflower stumps, the second, celery that has gone soft, outer leaves of lettuce and that sort of thing, nothing to inspire, so to it I should like to add a selection of wild roots which may from time to time add interest. Nobody in their senses is going to rush about digging like a crazy rabbit but if the roots of

wild flowers come your way on a holiday picnic place or rubbish dump, it seems even more silly to pass them over and, as often as not, destroy the restfulness of the picnic because 'I must get to the shops before closing to get something (more tired lettuce?) for the weekend'.

How about Salsify and Scorzonera for a start? The first has a white root, the second a black, but otherwise they'll pass for the same thing. Vegetable Oyster is another name and you'll still find them within the pale of the better seed lists and naturalised in the hedge banks of old gardens. Our native cousin, Goatsbeard, *Tragopogon pratensis* L., found in just the same dry grassy situation, is outside the pale; 'a dirty weed' for no better reason, so far as I can see, than that its dandelion-like flower is yellow rather than a dull purple and no thrifty but discerning peasant cooks have been at hand to extol its virtues. You can eat the buds and young shoots too if you wish, everything in fact bar the big 'clocks', larger and more brittle than a dandelion's, which are its identifying feature and just ripe for collecting seed for your own garden.

Other roots you can try include Silverweed and Great Burdock, that favourite of romantic watercolourists, who so often painted its huge leaves, filling in the foreground of the waterfall, ruined abbey or whatever was their main subject. Is it ungrateful of me to suggest that by the time you have done your best with spade and pick digging it up you'll be ready to eat anything? Yes, I see it is; on re-reading Mabey I see that I have tried it in winter and I should have picked it in summer and chopped it up fine to eat in Japanese fashion where the plant is sufficiently esteemed to be cultivated. Ah, well, one learns and I see I shall have to try again.

As a test of tenderness, you should be able to pick a salad shoot easily with finger and thumb: if it needs a knife, it needs cooking.

Watercress and Sorrel are the first two spring shoots which come to mind for salads, both so familiar as to allay fears of those conditioned by a greengrocer's shop. Sorrel, *Rumex acetosa* L., or Sourocks as it is known locally, has been picked and nibbled by most country children for its delicious citrus taste. In France it is so highly regarded that a superior type, *Rumex scutatus*, has been developed for growing in the garden but failing that, it seems simpler to go over the lawn with a bowl and preferably

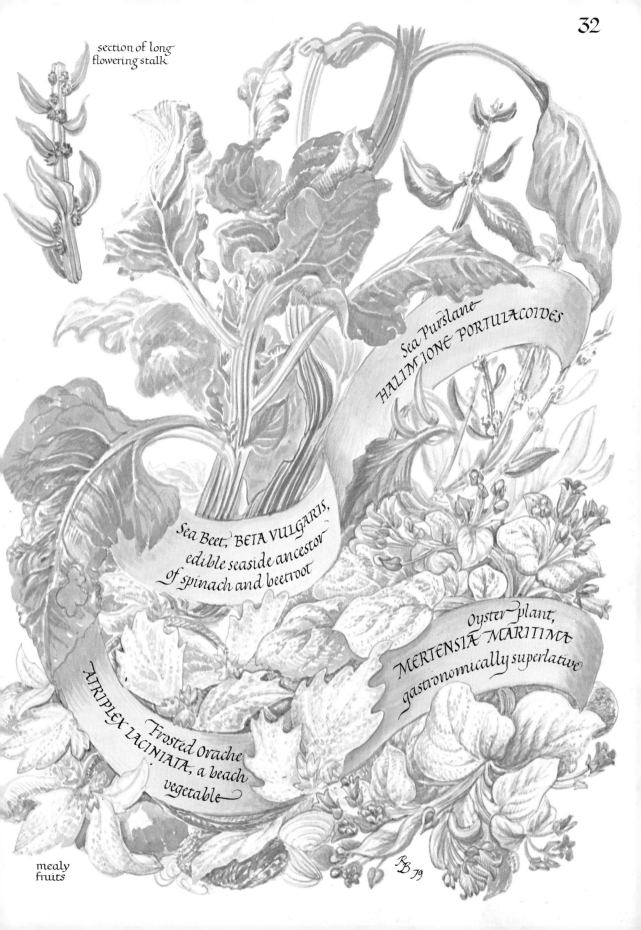

section of long flowering stalk

Sea Purslane HALIMIONE PORTULACOIDES

Sea Beet, BETA VULGARIS, edible seaside ancestor of spinach and beetroot

Oyster plant, MERTENSIA MARITIMA gastronomically superlative

Frosted Orache ATRIPLEX LACINIATA, a beach vegetable

mealy fruits

RB 79

Lady's Smock

a child or two, because you need lots of little fingers searching out the tender arrow-shaped leaves ten minutes before lunch. Even in the Highlands, one finds the Mountain Sorrel, *Oxyria digyna* (L.) Hill., small but very sharp to the taste and growing in the sort of place where vegetables are otherwise unobtainable.

Watercress is even more valuable because it can be gathered at any time of the year, being especially welcome during a mild spell in winter when you can make a really superb soup of any excess for the deep-freeze. On a basis of stock; potato and onion, liquidised, add milk and chopped watercress and bring to the boil, cook and freeze, not forgetting to put a few sprigs of watercress to one side in a separate little bag for garnishing. Reheat for serving, thicken with yolk of egg, season and sprinkle the garnishing leaves on top then Tante Marie herself couldn't swear that you hadn't flown it up from France that morning. As a child, I was always told only to gather watercress from clear running water. I can't remember then being told why but now know that it is because of the danger of picking up liver fluke from sheep or cattle, so cull watercress from streams where they have not been. I only mention these things, because I meet so many mothers who try to keep their children wrapped in cotton-wool. It's fair enough for babies but, as soon as a child is of an age to toddle off by itself, the sooner it develops some healthy antibodies the better; I should hate a child to be frightened out of discovering such basic joys as watercress and winkle teas by grown-up anxiety over waterborne diseases.

Watercress, formerly *Nasturtium officinale* R. Br. has now been classified as *Rorippa nasturtium – aquaticum* (L.) Hayek – which means that Mr R. Brown's classification has given way to that of von Hayek, confirming that of Linnaeus. Tiresome, one might think, about a bit of watercress but not nearly so tiresome in the long run, as the same plant turning up in, say, America or Japan, to be considered as different species and given different names. However, it leads us on to identify the other *Rorippae*, or Land Cresses, members of the huge family of *Cruciferae*, plants with simple four-petalled flowers in the shape of a cross.

American Land Cress, *Barbarea verna* (Mill) *Aschers Barbarea praecox* (Sm) R. Br. has a yellow flower. Personally, I find cresses very hard to

identify in the wild and the silly little shoot you want to have for lunch has withered beyond recall by the time you are sure of it. It is easier by far to grow even a few of the better known ones, tried and tested, in the garden. Cuckoo Flower, Lady's Smock, *Cardamine pratensis* L. is known to all by its soft mauve flower in spring. If you have a bit of damp grass it will settle down happily, giving sprigs for a salad at Easter and still leaving enough to flower at Whitsun before you cut it down later on as hay or in general tidiness.

Let us not forget Brooklime, *Veronica beccabunga* L., with egg-shaped leaves, not as dark as watercress and a bright blue flower because it, too, is edible. The real baddies to look out for are the Hemlock Water Dropworts, *Oenanthe* species, huge grey-green umbellifers growing in or by the water and, of course, trampling cattle upstream. I always remember this question of how far it takes running water to clear itself in our Highland burns. About a hundred yards is generally agreed to be safe, whereupon all have a good drink. Round the next rock a dead sheep discloses itself, and safety margins have to be reassuringly revised or the day is spoiled by the apprehensions of the ultrahygienic.

With Scurvy Grass one is on safer ground because this ancient Vikings' stand-by against Vitamin C deficiency on long sea voyages isn't a grass at all but another member of the cress family. It appears with the earliest spring wherever rock and dry grasses offer shelter, opening its little clusters of white cruciferous flowers in lush green nests of cordate leaves which ask to be tasted. There are six closely related species of *Cochlearias* which, I was comforted to note, even the Botanical Society of the British Isles have difficulty in sorting out: I'm not sure if I have eaten them all but the green heart-shaped leaves have a tart mustardy taste and are worth looking out for in seaside turf at Easter. As we live near to the sea, we prefer to pick them in the wild but I see no reason why you shouldn't introduce them to the garden if you can match the exact degree of well-drained wetness they seem to want.

I don't pretend for a moment that it isn't quicker and easier to nip into the supermarket for sprouts/lettuce/tomatoes when one is rushing home in a hurry from the office but do people always want to spend their whole

lives working flat out, rushing, driving, parking, shopping? Pre-industrial ages were old, bad, labour-intensive and back-breaking we know but, when leisure is increasingly to be a problem for automated man, can they not teach us something.

The seaside is particularly rich in edible shoots which is lucky, because it is when people are in holiday mood with time on their hands that they are more likely to feel like experimenting.

As well as Scurvy Grass, the *Cochlearia* species which I have mentioned because it is at its best before most people have thought about the seaside, there are several species easy to find and identify as well as good to eat.

Among seaside plants which are well worth getting to know are Samphire, *Crithmum maritimum,* or Rock Samphire and Glasswort, *Salicornia europaea.* They provide an instance of the importance of Latin clarity, because to confuse you, Glasswort is sometimes called Marsh Samphire. What they have in common is excellence and their habit of growing in the most delightful places as far from a supermarket as you can possibly get, Glasswort out on the tidal mud flats of East Anglian estuaries and Rock Samphire on the cliffs of the south-west, the sort of places you don't want to leave to go shopping on a summer's day. The salty shoots are delicious eaten straight away. Later on there are more ambitious ways of cooking them as a vegetable or even pickling them in brine like gherkins or sauerkraut for winter use.

Other semi-succulent plants which will yield tender shoots to your salad include the Stonecrops; *Sedum reflexum,* yellow with leaves bent back; *S. album L.,* white and both found on every rockery with the little yellow Wall Pepper, *S. acre* L. However many barrowfuls must I, must we all have carted away to the heap? For me no longer, as I kneel weeding the flagstones, tidying up the Stonecrops in summer after their flowering, the barrow doesn't need emptying quite so often because I have a bowl in which to put young shoots for the kitchen. By the sea it's even better sitting on a sun-baked rock sorting out succulent shoots from twiddly roots, the perfect holiday occupation for an idle hour to be ranked with winkle-picking and shrimping.

Edible roots which, alas, today I must rule out, include sea holly, sea

Sea Holly

kale, rampion and oyster plant simply because they have become so rare. Sea holly I remember to have been quite plentiful on the Suffolk coast in the thirties, but that was before dried-flower arrangements became such a cult: it seems a pity that a plant should be driven to extinction by rapacious fingers of its professed admirers.

Sea Kale is another formerly common denizen of the shingle banks: the few plants I know seem to be fighting a losing battle against vandalism simply because people can't believe that such a large 'cabbage' is really growing on the beach and take random swipes at it. However, there are still the odd clumps of it protected, if inadvertently, by Army firing ranges on the east coast and it is a memorable experience to look across the water at Sea Kale. At first you think you are looking at a distant line of breakers till you realise that it is neither rough enough for such a sea to be running nor can you hear it. Then, with the aid of binoculars, you see that your line of breaking surf is still – as still as the great wave of Hokusai's picture – and that the lace-like foam flung up on its rearing green crest is as dry as the seventeenth-century master's woodcut. This seeming mirage on the horizon is made up of millions of little white flowers and you realise that you are witnessing the flowering of Sea Kale, *Crambe maritima* L. If only people wanted to lift up their hearts, there would be special excursions to see such a miracle and if only they cared for their palates, there would be a local cottage industry cultivating it along the shingly foreshore as they did in Regency days: little eating places where people could eat Sea Kale served in Hollandaise sauce to follow the oysters which are already so deliciously and, I imagine, profitably farmed for visitors to the Aldeburgh Festival.

Kaffir Fig

Oyster Plant, too, is another of our disappearing species. Formerly it was found on many shingle banks round our coast and only a few years ago I remember it plentiful in Caithness. Now it has retreated more or less to its headquarters in Orkney but though I have known misguided gardeners try to dig up a bit, thinking that it would make a charming addition to their rockeries without realising that it needs to writhe through the shingle on a stalk like a garden hose, the culprits in this case are the sheep. They graze along the shore and, indeed, anyone who has ever been favoured with a piece of Orkney lamb, knows to what good purpose.

'Grazing on the seaweed', say the Orcadian farmers but I have watched them browsing along the northern shore and, given a chance, they'll go for Oyster Plant any time. This is a pity but who can blame them? The leaves are semi-succulent, ranging in colour from the most delicate pea-green shoots to a washed-out sea-blue covered in tiny warts when mature and even reddish when old. If you just eat one raw, the texture and taste of oysters is most marked and delicious, so I don't know what can be done about it. Perhaps some of the surviving clumps could be wired in against the sheep – mini-reserves just along the vital few yards at the high-tide mark where the terns nest? If the decline of this species could only be

arrested perhaps one could dream up a delicate little dish of Oyster Plant and seafood, as the tiny butterfly shells, the inhabitants of which one eats as '*Tellines*' in the South of France, are plentiful round our northern shore. Once fashionable interest can be engaged there is hope and money to pay for conservation, so I am unwilling to be dismissed as a nut-case when we have the example of Dublin Bay prawns before us. Considered only as food fit for the Irish peasants till the post-war tourist boom rediscovered them as Mediterranean scampi, they are now, monetarily, the fourth most valuable species to be fished from the sea – Soho restaurateurs even have special cutters to trim monkfish near enough to their semblance to get by under a thick sauce. It seems a pity that Oyster Plant is likely soon to disappear from our shores because only sheep realise how good it is.

Fennel and mallow are to be found on warmer shores than Fife's and you can even eat the fruit of that hideous great Kaffir Fig, *Mesembryanthemum crystallinum,* with shrill pink flowers like sea anemones which is to be seen sprawling all over the sun-trap rockeries, cliff pavilions and traffic islands of south coast resorts. The fruit, sour or kaffir fig may be cooked in a bredy like pumpkin. The coarse thing was brought in from South Africa but before anyone writes to the Race Relations Board, let me mention the modest and seemly little grey Jersey Cudweed, *Gnaphalium luteoalbum* which has gone off to South Africa, where I'm told it grows a yard high and the natives of the Cape of Good Hope pick it like spinach. Can we not encourage it to spread along our south-east coasts instead?

Commonly to be found along our shingle beaches is Sea Beet, *Beta vulgaris* L., ancestor of both cultivated species of spinach and beetroot as you can often see by the red-ribbed stalk of an old plant in late summer. Don't attempt to pick any but young shoots and look carefully under old foliage as such cool shade of decaying vegetation will often produce a dish of fat snails for dinner instead.

Sea Purslane, *Halimione portulacoides* (L.) Aellen., has oval fleshing grey leaves and reddish stalks. It grows commonly along the muddy estuaries of the south-east – the sort of places people like to spend their time in a boat rather than in a supermarket – and is quite good to rinse in seawater and add to a salad.

Living in a Wild Garden

The Common Buckthorn, *Rhamnus cathartica* L., and Alder Buck-thorn, *Frangula alnus* Mill. are both poisonous yet Sea Buckthorn, *Hippophae rhamnoides.* is no relation. The last, which is classified as sole representative of the Oleaster family, *Elaeagnaceae,* is to be found on a dreadful page of universal poison with mistletoe, bastard toadflax, dog's mercury and all the spurges, yet has edible berries. It leads me to suspect that botany is the sort of subject in which you must know all or nothing. All I can do is to trust my eye in correct identification and my stomach. We don't get the poisonous buckthorns up here in Scotland but our coasts are covered mile after mile with Sea Buckthorn to the delight of birds migrating from Scandinavia, which arrive just as the ripe berries turn the grey-leaved bushes to flame. I haven't yet worked out a distinctive recipe but I will if I can.

Lovage, *Ligusticum scoticum* L., is found growing wild all round the Scottish coast yet hardly at all in England. Brought into the garden and given decent treatment, it will respond in producing its celery-like foliage and flower umbels just like the garden herb. We have, on occasion, cooked the stalks and used the shoots chopped in salads but as Lovage is such a fine-looking plant, it seems a pity to disfigure it. However, as in all umbellifers, seedheads are the defining feature; those of Lovage are oval and have such prominent ridges as to appear flanged. My need is to have additions for the bread so I leave them to ripen on the plant, then gather them carefully one fine day in September.

Lovage seeds×2

Lovage shoots

Though in Cupar, we are lucky in still having real bakers who bake real bread to defend us from convenience junk food, so that no-one need positively court cancer of the colon, I still like to bake my own as a treat. You need a winter's day, preferably with a good fire in the kitchen and bad weather out of doors, to set the scene for this most ancient of cooking rituals.

Baking bread is the opposite of pastry-making, in which you keep everything cool and the less it is touched the lighter it is: dough must be kept warm for the yeast to work in it and the more pummelled and thumped it is the better. On the hob you place your yeast to become activated in a bowl of warm milk and, on the hearth, a dozen scoopfuls of flour, rough brown from the mill down the hill with plenty of salt in a big crock to warm. I seem to use about a stone but it is never any good asking me about weights and measures as I seldom use them. Cooking is an art of nothing. It is a matter of temperament. One cooks as one paints, with love, patient care and taste, constantly testing with the eye or a licked finger: mathematical exactitude will produce as inspired a result as painting by numbers.

Ordinary DCL tinned yeast compensates in convenience for any inferiority to fresh plant from a maltster. Once it is all working, with a good head on it like stout, pour it into the flour and add enough warm water to achieve a wet dough. Covered with a cloth and left in the warm, this will rise in about an hour. If you haven't an open fire or stove some people use an airing cupboard. In the Antarctic we used the top of the hot water tank; anywhere warm and out of a draught will do. When the dough has risen, you roll up your sleeves to knead it, pummelling down the great honeycombed dome of dough with your fists and folding sides to middle. This is hard work and it is wise to wedge the crock against the back of a chair so it can't jump about by adhering to the dough. You knead bread for ten minutes to produce an even texture without air holes and the exercise is

good for you. Years ago women pumped water, chopped wood, pounded the washing, shook the rugs, beat the carpet and thumped their brats, till by the end of the day they were tired out but triumphant, now they fiddle with so many switches in their labour-saving kitchens and have such guilt feelings about beating their children that they have to ring up their psychiatrists instead.

If anything intervenes and your attention is distracted for an hour from your bread-making, it doesn't matter, you simply knead it down again. Nothing can harm it but freezing cold to kill the yeast and, even then, you can start again with a fresh lot. That is why bread-baking is such a satisfactory occupation and therapy. Add eggs, half a dozen or so, because what is the point of keeping hens, if you have to count the eggs and cannot feel that you can just throw them in with Victorian largesse?

Yeast, flour, salt and water is all you basically need for bread, rough peasant stuff which, after a final knead, you place in greased tins to prove into shaped loaves for the oven; shape them yourself to get maximum crust or place little rolls on baking sheets which are, incidentally, easier to wash than tins. Half an hour to an hour, according to size, in a moderate oven will bake your bread. You'll know when a loaf is cooked through because its bottom is browned and has a crusty ring about it rather than a soggy thump when you rap it with your knuckles before turning it out on a rack to cool.

If you are going to the trouble of making bread and washing up afterwards, it seems silly not to ensure that it will be better than anything you can buy in a shop, really the Staff of Life, a meal in itself, with enough to give to friends and stock the deep freeze for a month. So put in a good dollop of fat, oil or butter, if you can spare it, and a handful of everything that occurs, as you browse along the kitchen shelves; a little brown sugar to sweeten it perhaps? Even for a change some currants? By dividing the dough you can make several different sorts. Mixed spice and mixed herbs will make it more savoury than any bread you have ever tasted, and sage, which I always bring in from the garden in huge branches of 'prunings' and my wife finds a herb too coarse to be of much use in her cooking, does very well in bread.

Celery seed and celery salt come into the same category so it is then but a natural step to Lovage; leaves and seeds inside, I can't grow enough of it. Any more seeds to spare on top. Nowhere, however, can I find any other recipes making use of this estimable herb. I can understand people not being encouraged to discover the culinary possibilities of, say, cudweed and wormwood, but Lovage one would have thought would go straight to anyone's heart. So come on, all you herb garden ladies and discerning chefs. Just glance at the distribution map of *Ligusticum scoticum* running round the coast from Lothian to Solway and let's have a little flair.

If an eighteenth-century French Maître de Cuisine, confronted by olive oil and scraggy hens laying tiny eggs in Majorca, could invent mayonnaise, must it remain beyond our wits to dream up some new Scottish dishes, equally acceptable internationally, making use of Lovage, Spignel-meu and Oyster Plant, species which, like grouse, are only to be found in Scotland?

Bibliography

Botanical Atlas of the British Isles Botanical Society for the British Isles (1976)

Complete Herbal Nicholas Culpeper (Foulsham, 1952)

Concise British Flora in Colour W. Keble Martin (Michael Joseph & Ebury Press, 1969)

Concise Encyclopaedia of Gastronomy André Simon (Collins, 1952)

Encyclopaedia of Gardening Percy Thrower (Hamlyn, 1978)

Fat of the Land John Seymour (Faber, 1974)

Field Guide to the Insects of Britain & Europe Michael Chinery (Collins, 1973)

Flowers of Europe: A Field Guide Dr Oleg Polunin (OUP, 1969)

Food for Free Richard Mabey (Collins, 1972)

Guide to Mushrooms and Toadstools Morten Lange & F. Bayard Hora (Collins, 1963)

Herbal Handbook for Everyone Juliette de Bairacli Levy (Faber, 1966)

How to Enjoy Your Weeds Audrey Wynne Hatfield (Muller, 1974)

Leaves from our Tuscan Kitchen Janet Ross and Michael Waterfield (Murray, 1978)

Mushroom Feast Jane Grigson (Michael Joseph, 1975)

Old Shrubs and Roses Graham Stuart Thomas (Phoenix House, 1963)

Cold Comfort Farm Stella Gibbons (Allen Lane, 1976)

Achillea millefolium **illus 83**, 95
Acinos arvensis **illus 42–43**, 52
Aconitum vulparia 98
Aegopodium podagraria **illus 59**, 66–67
Aethusa cynapium **illus 35**, 46, 48
Agaricus bisporus 82
 A. langei 81
Agropyron repens **illus 80**, 89
Alchemilla mollis **illus 62–63**, 66
Alehoof 101, **illus 101**
Alexanders **illus 38**, 48
Alliaria petiolata **illus 54**, 61
Allium paradoxum **illus 10**, 16
 A. roseum **illus 10**
 A. schoenoprasum **illus 10**, 15
 A. sphaerocephalon **illus 10**, 15
 A. triquetrum 16
 A. ursinum **illus 10**, 13
 A. vineale 15
Amanita muscaria 79
 A. phalloides 78
 A. rubescens **illus 68**, 79
 A. virosa 78
Anchusa 104
Angelica archangelica **illus 50–51**, 60
 A. sylvestris **illus 50–51**, 60
Angelica, Wild **illus 50–51**, 60–61
Anthriscus sylvestris **illus 35**, 46
Armillaria mellea 82
Armoracia rusticana **illus 42–43**, 55
Arnica **illus 83**, 93
Artichoke, Globe 41, *illus 41*
Atriplex hastata 69
 A. laciniata 69, **illus 115**
 A. patula 69
Auricularia auricula 84

Balm **illus 42–43**, 52
Barbarea verna **illus 97**, 116
Basil Thyme **illus 42–43**, 52
Bats in the Belfry **illus 38**, 49
Bay 25
Beech *illus 26*, 27
Beefsteak Fungus **illus 73**, 82–84
Bellis perennis **illus 80**, 95
Bergamot 106
Beta vulgaris **illus 115**, 121
Bilberry **illus 47**, 58
Bindweed, American **illus 94**, 102–103
 Field 90, 102
 Great 102–103, *illus 102–103*
Bishop's Weed **illus 59**, 66–67
Bistort **illus 54**, 64
Blackberry **illus 47**, 58
Blackcurrant 56
Blackthorn **illus 17**, 26
Blaeberry 58
Blewit 85
 Wood **illus 68**
Blueberry 58
Blusher **illus 68**, 79
Bolée 87, 74
Boletus, Devil's 88
 B. edulis **illus 73**, 88
 B. elegans 88
 B. felleus 88
 B. luridus 88
 B. piperatus 88
 B. satanas 88
 B. scaber 88, *illus 89*
Borage **illus 91**, 104
Boraginaceae 104
Borago officinalis **illus 91**
Bracken 71
Bramble **illus 47**, 58
Brooklime **illus 109**, 117
Broom 106
Buckthorn, Alder 122
 Common 122
 Sea 122
Bugbane 98
Butterbur **illus 62–63**, 70
Buttercup, bulbous 106–107, *illus 107*

creeping 106
crowsfoot 106

Calendula officinalis **illus 80**, 92
Calystegia sepium 102
 C. sylvestris **illus 94**, 102
Campanula latifolia **illus 38**, 49
Cantharellus cibarius **illus 73**, 87
Caper Spurge **illus 77**, 92
Cardamine pratensis 117
Catmint 52, **illus 91**, 96, 101
Cep 74, 87
Chaenomeles japonica **illus 47**, 58
Chamaenerion angustifolium **illus 2**, 19
Chamomile **illus 21**, 31, 93
Chanterelle **illus 73**, 74, 87–88
Chenopodium album 69
 C. bonus-henricus **illus 62–63**, 69
Cherry, Bird 25
 Sour 25
 St Lucy's 25
Chickweed 9, **illus 65**, 72
Chicory **illus 100**, 110–111
Chives **illus 10**, 15
Chrysanthemum leucanthemum **illus 42–43**, 53
 C. parthenium **illus 21**, 31, 93
 C. vulgare **illus 91**, 98
Cichorium intybus **illus 100**, 110
Cimicifuga racemosa 98
Clary 95
 Meadow **illus 83**, 106
Cleavers **illus 59**, 66, *illus 66*
Clitocybe flaccida 87
Clover, Dutch **illus 6**
 Red **illus 6**, 15
 White **illus 6**, 15
Cochlearia species 117–118
Coltsfoot **illus 65**, 71–72, 90
Comfrey 99
 Tuberous 99, *illus 99*
Conium maculatum **illus 35**, 46–48
Convolvulus arvensis 102
Coprinus comatus **illus 65**, 75, 76
 C. atrimentarius **illus 65**, 75
Cornflower 110
Couch Grass **illus 80**, 89–90
Cow Parsley **illus 35**, 46
Cowslip 106
Crambe maritima 119
Crithmum maritimum **illus 112**, 118
Cuckoo Flower 117
Cudweed 121, 125
Cydonia japonica 58
Cynara scolymus 41

Daisy **illus 80**, 95
 Ox-eye **illus 42–43**, 52, 53
Dame's Violet **illus 54**, 61
Damson 57–58
Dandelion **illus 14**, 22–23, *illus 23*
Day Lily **illus 97**, 103–104
Deadly Nightshade 9, *illus 9*
Death Cap 78, *illus 78*
Destroying Angel 78
Dianthus armeria 49
 D. deltoides 49
 D. gratianopolitanus 49
Dishie Laggie 72
Dock, Broad-leaved **illus 80**, 95
Dog's Mercury **illus 59**, 67–69, 122
Doronicum pardalianches **illus 83**, 93
Dry Rot 81–82

Elaeagnaceae 122
Elder **illus 50–51**, 56–57
Elecampane **illus 86**, 95
Equisetum arvense 70
Euphorbia lathyrus **illus 77**, 92
Euphrasia officinalis **illus 83**, 93
Eyebright **illus 83**, 93

Fat Hen 69
Fennel 121
Feverfew **illus 21**, 31, 93
Filipendula ulmaria 96, **illus 94**
Fireweed 19
Fisherman's Fungus *illus 79*, 81
Fistulina hepatica **illus 73**, 82
Fleabane 98
Fly Agaric *illus 78*, 79
Fool's Parsley **illus 35**, 46, 48
Frangula alnus 122

Galium aparine **illus 59**, 66
 G. odoratum **illus 94**, 97
 G. verum **illus 80**, 95
Garlic, Crow 15
 Wild **illus 10**, 13, 16, 18
Garlic Mustard 61
Gean 25, *illus 25*
Girolle 87
Gladiolus illyricus 107
Glasswort **illus 112**, 118
Glechoma hederacea 101
Gnaphalium luteoalbum 121
Goatsbeard **illus 105**, 114
Good King Henry **illus 62–63**, 69
Gooseberry 56, *illus 56*
Goosegrass 66
Goutweed 66
Great Bellflower 49
Great Burdock 114
Gros vert de Laon 41
Ground Elder **illus 59**, 66
Ground Ivy 101

Halimione portulacoides **illus 115**, 121
Helianthus annuus **illus 28–29**, 34
 H. tuberosus **illus 28–29**, 40
Helvella crispa 30
Hemerocallis fulva **illus 97**, 103
Hemlock **illus 35**, 46, 48
 Water Dropwort **illus 109**, 117
Heracleum mantegazzianum 46
 H. sphondylium **illus 32**, 46
Hesperis matronalis **illus 54**, 61
Hippophae rhamnoides 122
Hogweed, Giant 46
 Common **illus 32**, 46
Honesty, 12, *illus 60–61*, 61
Honey Fungus 82, *illus 84*
Hops, 101, *illus 101*
Horseradish **illus 42–43**, 55
Horsetail 70, *illus 71*
Humulus lupulus 101
Hygrophoropsis aurantiaca **illus 73**, 87

Inula helenium **illus 86**, 95
Ipomeia species 103

Jack-by-the-hedge **illus 54**, 61
Jerusalem Artichoke **illus 28–29**, 39, 41
Jew's Ears *illus 85*, 84

Kaffir Fig *illus 120*, 121

Laccaria amethystina **illus 68**, 85
Lady's Bedstraw **illus 80**, 95
 Mantle **illus 62–63**, 66
 Smock *illus 116–117*, 117
Lamb's Lettuce **illus 62–63**, 69
Lamium album **illus 6**, 15
 L. purpureum 15, **illus 65**
Land Cress 116
 American **illus 97**, 116
Lapsana communis 95
Laurel, Cherry 25
 Common **illus 17**, 25
 Portugal **illus 17**, 25
Laurus nobilis 25
Lawyer's Wig **illus 65**, 75
Leek, Few-flowered **illus 10**, 16
 Round-headed **illus 10**, 15
 Three-cornered 16, *illus 18*

Leopard's Bane illus **83**, 93
Lepiota rhacodes illus **73**, 81
Ligusticum scoticum 122, 125
Lime, Broad-leaved 27
 Common illus **21**, 27, 30
 Narrow-leaved 27
Lovage 122, *illus 122, 123*, 125
Lunaria species 61
Lycoperdon caelatum illus **42–43**, 78
 L. excipuliforme illus **42–43**, 78
 L. giganteum illus **42–43**, 76, 78

Mallow, 121
Marigold 12, illus **80**, 92
 African 92
 French 92
Marjoram illus **42–43**, 52
Marrow 34, 36
Meadow Sage 95
Meadowsweet 96, *illus 94*
Melissa officinalis illus **42–43**, 52
Mentha aquatica illus **24**, 33
 M. citrata illus **80**
 M. longifolia illus **24**, 31
 M. piperita illus **21**, 31
 M. rotundifolia illus **24**, 31
 M. spicata 24, illus **31**
Mercurialis perennis illus **59**, 67
Mertensia maritima illus **115**
Merulius lacrymans 81–82
Mesembryanthemum crystallinum 121
Mint *illus 33*, 33
 Apple illus **24**, 31
 Eau de Cologne illus **83**, 93–95
 Horse illus **24**, 31
 Peppermint illus **21**, 31
 Spearmint illus **24**, 31
 Water illus **24**, 31, 33
Monarda didyma 106
Money-flower 61
Montia perfoliata illus **38**, 49
 M. sibirica illus **38**, 49
Morning Glory 103
Mountain Ash illus **47**, 58
Mushroom, Common 79–81
 Oyster *illus* **68**, 84
 Wood 81
Mycelis muralis illus **62–63**, 69
Mycena pura 85
Myrrhis odorata 48, illus **50–51**

Nasturtium illus **97**, 104
 N. officinale 116
Nepeta glechoma 101
Nettle, Annual illus **2**, 13
 Purple Dead 15, illus **65**
 Stinging illus **2**, 11–13, 56
 White Dead illus **6**, 15
Nipplewort 95
Norway Maple *illus 27*

Oenanthe crocata 48, illus **109**
Oraches, Common 69
 Frosted 69, illus **115**
 Hastate 69
Origanum vulgare illus **42–43**, 52
Oxalis acetosella illus **54**, 61–64
Oxyria digyna 116
Oyster Plant illus **115**, 119, 120–121, 125

Papaver dubium 52
 P. rhoeas illus **42–43**, 52
 P. somniforum 53
Parsnip 108–110, *illus 110*
Penny Bun illus **73**
Petasites fragrans illus **62–63**, 70
 P. hybridus illus **62–63**, 70
Pink, Cheddar *illus 48*, 49

Deptford 49, *illus 49*
 Maiden *illus 48*, 49
Piptoporous betulinus 81
Pleurotus ostreatus illus **68**, 84
Polygonatum multiflorum illus **59**, 64
Polygonum bistorta illus **54**, 64
 P. persicaria illus **42–43**
Poppy, Common Red illus **42–43**, 52, *illus 53*
 Opium 53, *illus 53*
Prunella vulgaris illus **80**, 95
Prunus avium 25
 P. cerasus 25
 P. domestica 57
 P. laurocerasus illus **17**, 25
 P. lusitanica illus **17**, 25
 P. malaheb 25
 P. padus 25
 P. spinosa illus **17**, 26
Puffball, Common illus **42–43**, 76–78
 Giant illus **42–43**, 76–78
 Mosaic illus **42–43**, 78
Pulicaria dysenterica 98
Pumpkin 34, 36–37
Purslane, Pink illus **38**, 49
 Sea illus **115**, 121

Queen Anne's Lace illus **35**, 46
Quince illus **47**, 58

Radish illus **97**, 111
Rampion 119
Ramsons illus **10**, 13
Ranunculaceae 106
Raphanus sativus illus **97**, 111
Redleg 9, illus **42–43**, 52, 53, 64
Rhamnus cathartica 122
Rheum rhaponticum 44
Rhubarb, Champagne 44–45
 Monks' 44, *illus 44–45*
Rorippa nasturtium-aquaticum illus **109**, 116
Rosa alba semi-plena illus 12–13
 R. damascena 12
 R. francofurtana 12
 R. henryi 103
 R. macrantha 103
 R. paulii 12
 R. rugosa 58
 R. rugosa scabrosa illus **47**, 58
Rose, China illus **47**, 58
 Damascus 12
 Dorothy Perkins 103
 Gloire de Dijon 7
 Souvenir de L'Imperatrice Josephine 12
 Variegata di Bologna 12
 White Rose of York *illus 12–13*
Rose Bay Willowherb illus **2**, 19–22, *illus 22*
Rowan illus **47**, 58
Rubus fruticosus illus **47**, 58
Rumex acetosa 114
 R. alpinus 44
 R. obtusifolius illus **80**
 R. scutatus 114

Sage 124
Salicornia europaea illus **112**, 118
Salsify illus **105**, 114
Salvia pratensis illus **83**, 95, 106
 S. horminoides 95
Sambucus nigra illus **50–51**
Samphire 118
 Marsh illus **112**, 118
 Rock illus **112**, 118
Saponaria officinalis illus **91**, 96
Scorzonera 114
Scurvy Grass 117–118
Scutch 89
Sea Beet illus **115**, 121

Holly 118–119, *illus 119*
Kale 119
Sedum acre 118
 S. album 118
 S. reflexum 118
Self-heal illus **80**, 95
Shaggy Inkcap illus **65**, 75–76, 78
 Parasol illus **73**, 81
Shii-take 84–85
Silverweed 114
Sloe illus **17**, 26
Smyrnium olusatrum illus **38**, 48
Snakeroot 98
Snakeweed 64
Soapwort illus **91**, 96, *illus 96*
Solomon's Seal illus **59**, 64
Sonchus arvensis illus **62–63**, 70
Sorbus aucuparia illus **47**, 58
Sorrel 114–116
 Mountain 116
 Wood illus **54**, 61–64
Sourocks 114
Sowthistle, Corn illus **62–63**, 70
Spring Beauty illus **38**, 49
Spignel-meu 125
Stellaria media illus **65**, 72
Sticky Willy illus **59**, 66
Stonecrop, Yellow 118
 White 118
Succory 110
Sukebind 19
Sunflower illus **28–29**, 33–34
Sweet Cicely 48, *illus 48*, illus **50–51**
Sweet Rocket illus **54**
Sycamore 27, *illus 30*

Tagetes species 92
Tansy illus **91**, 98
Taraxacum officinale illus **14**
Taxus baccata illus **17**
Thyme, Wild illus **42–43**, 52
Thymus drucei illus **42–43**, 52
Tilia cordata 27
 T. platyphyllos 27
 T. vulgaris illus **21**, 27
Tragopogon porrifolius illus **105**
 T. pratensis illus **105**, 114
Trifolium pratense illus **6**, 15
 T. repens illus **6**, 15
Tricholoma nudum illus **68**, 85
 T. saevum illus **68**, 85
Trompettes des morts 74, *illus 75*
Turnip 107–108
 Globe 108
Tussilago farfara illus **65**, 72
Twitch 89

Urtica dioica illus **2**
 U. urens illus **2**, 13

Vaccinium myrtillus illus **47**, 58
Vegetable Oyster 114
Verbena officinalis illus **21**, 31
Veronica beccabunga illus **109**, 117
Vervain illus **21**, 31
Viper's Bugloss 104, *illus 10*

Wall Lettuce 69
 Pepper 118
Watercress illus **109**, 114, 116–117
Whortleberry illus **47**, 58
Wild Shamrock illus **54**
Winter Heliotrope illus **62–63**, 70
Witch 89
Wolf's Bane 98
Woodruff illus **94**, 96

Yarrow illus **83**, 95
Yew illus **17**, 26–27